Painting with Light

Painting with Light

BY BETTY L. SCHLEMM
EDITED BY CHARLES MOVALLI

WATSON-GUPTILL PUBLICATIONS / NEW YORK
PITMAN PUBLISHING / LONDON

First published 1978 in the United States and Canada by Watson-Guptill Publications,
a division of Billboard Publications, Inc.,
1515 Broadway, New York, N.Y. 10036

Published in Great Britain by Pitman Publishing Ltd.,
39 Parker Street, London WC2B 5PB
ISBN 0-273-01215-0

Library of Congress Cataloging in Publication Data
Schlemm, Betty L. 1934-
 Painting with light.
 Bibliography: p.
 Includes index.
 1. Watercolor painting—Technique. 2. Painting—
Technique. 3. Light in art. I. Movalli, Charles.
II. Title.
ND2420.S34 1978 751.4'22 77-26082
ISBN 0-8230-3881-5

Manufactured in Japan

First Printing, 1978
Second Printing, 1979

*This book is dedicated
to my mother, my father, and my sister
Elizabeth and her family.*

Contents

Introduction

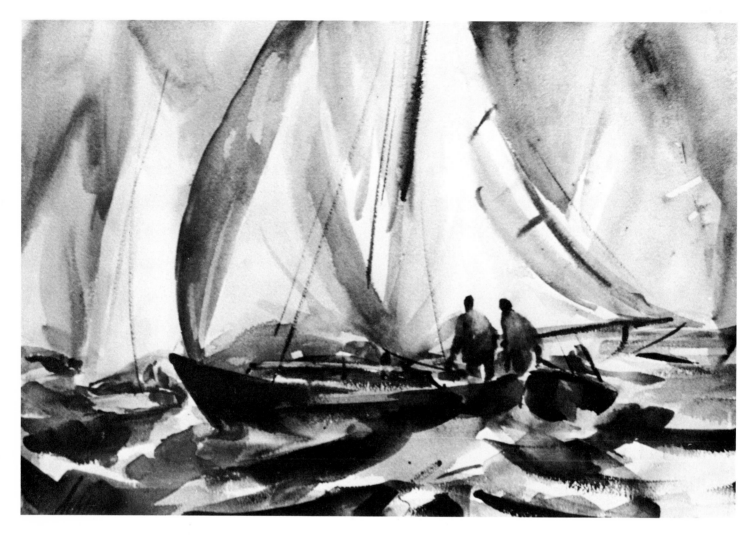

SUNDAY SAIL, *14" x 20" (36 x 51 cm), collection of Edward J. Franco. I painted this picture from a small rowboat and had to work rapidly, catching the crafts on paper as they raced by me. The boats in each class are all similarly designed, so although I started work by brushing in one boat, I could use the other boats for reference once the first had sailed on. The out-of-light sides of the sails were established first—then the sky and water were painted. I used these darks to establish my all-important light pattern.*

Light started the world. And for me it's one of the most important things in painting. In the following chapters, I hope to explain some of my views about light and how light can add life and vitality to your work. I'll discuss theory first—and then, in eight demonstrations, show how the ideas can be applied to a series of problems.

In the process, I hope I can also get you to think like a painter—a painter who happens to express himself through the medium of watercolor. The same basic thinking lies behind both oil and water-color painting. Only the aims and techniques differ. The oil painter approximates and corrects. The watercolorist can't guess—he has to *know*. The oil painter is like a novelist; he can work on a painting for months. The watercolorist, on the other hand, is a poet. His specialty is the simple effect, the quick statement. He works by elimination, by paring a subject down to its essentials. Watercolor, therefore, is a perfect medium for catching effects of light—a medium that's fresh, alive, and responsive to the moment and the shifting moods of nature.

Materials

Here are my main painting materials: easel, sketchpad, paper, brushes, palette, sponge, canteen, clips to hold my paper, a visor to keep the sun out of my eyes, and a sack to hold it all.

Before talking about light and its uses in a watercolor, let's quickly discuss our basic materials.

EASEL. I like the Winsor&Newton sketch easel. Its legs have a decent spread—more than you get on the usual chain-connected models. And it's very light—only about three pounds. When painting outdoors, I weight it down in the wind by tying one of the legs to an old pillowcase filled with rocks. The tray on which the drawing board rests is narrow; it's only two inches (5 cm) wide, compared to the four and a half inches (11.5 cm) of the average American easel. That creates a stability problem; but I feel the disadvantage is more than offset by the easel's convenience—it can actually fit inside a suitcase! It comes in both a finished and unfinished form, the latter being much less expensive.

PALETTE. I use the so-called O'Hara Palette. It has places for paints along the side and a flat center area for mixing—just like an oil painter's palette. A sweep of a wet brush cleans it. It's a comfortable palette, big enough to work on, yet small enough to hold in your hand. The only problem is that it's made of metal and has a tendency to rust. So when you get your watercolor palette, immediately coat the surface with Rustoleum. Spraying the palette with transparent acrylic Krylon also seals and waterproofs it. Take either of these steps, and the palette will last for years.

DRAWING BOARD. A piece of tempered Masonite makes a good waterproof board for mounting your paper. Treat your drawing board with care—don't kick it, cut it, or do anything to damage its surface.

WATER CANTEEN. Watercolor needs water—and plenty of it. But many students start with a cupful! Get a regular Army canteen set—or use a big coffee can. And remember to keep changing your water, so it's nice and clean.

RAGS. Use rags rather than paper tissues to take water off your brush—they're stronger and more absorbent. When I paint, the brush always goes directly from the water into the rag. How long I hold it there determines the character of my stroke.

PENCIL. The point of a hard pencil digs into your paper, and the lead of a soft pencil will actually dissolve and dirty your wash. So use a regular No. 2 writing pencil—or an HB-grade drawing pencil.

KNEADED ERASER. A standard pencil eraser is so hard that it hurts the surface of your paper. A soft kneaded eraser is much safer.

SPONGE. Never use tissues, rags, or a synthetic sponge to clean your paper. They're much too harsh. A natural sponge treats the paper as it should be treated—like a young child. Carry extra sponges with you outdoors. The sponge looks like a gray rock—so when you drop one, it's almost impossible to find.

BRUSHES. Nothing is more personal than the choice of brushes. Some people use two- or three-inch (5 or 8 cm) brushes and put down washes that look as if they'd been made with a roller. But I prefer a more personal sort of stroke, a stroke that lets you feel the artist moving with the paint. So I use a one-inch (2.5 cm) flat, *synthetic* "sabeline" brush, either that made by Grumbacher or by ArtSign (the "Aquarelle" model). They cover areas quickly, giving you speed when you're working outdoors. You can draw with them—and get a good chisel edge, too.

Of course, I can't do everything with a flat. I also have rounds: Nos. 10, 8, and 4. The round is a sensitive brush and gives you an "artistic" line. If you can only afford two brushes, get a one-inch (2.5 cm) flat and a No. 8 round.

GLASS. In my studio, I use a small piece of glass (taped around the edges) for testing possible corrections. In Figure 1, for example, I've painted a dory on the glass and can move it around, searching for the best compositional arrangement. Of course, the glass is a terrible painting surface—but it suggests how the final correction will look.

PAPER. Paper comes in various grades. The cheapest paper is made of pulp and isn't good for our purposes—it deteriorates too rapidly. Try to get 100% rag paper, made from either cotton or linen. You can also try some of the new synthetic papers, popular now that cotton and linen rags are hard to find.

We need a paper that holds a wash when we glaze over it, but which isn't so absorptive that the washes are impossible to remove—I want to be able to make corrections. There are a number of different types of paper:

Hot Press. Hot-press papers take a good wash. But they're smooth and hard; the paint stays on the surface and when you glaze over a wash, it immediately lifts. Hot press works if you paint direct—but not if, like myself, you prefer to work one wash over another.

Rough. Rough paper takes big washes, and it's useful if you like "texture." The first wash settles in the valleys of the paper; later washes catch the upper surface, creating interesting rough-brush effects. You have to be careful with your first washes, however; skimp on your water and you'll leave flecks of white paper everywhere. And these spots of paper will destroy your big light-dark pattern.

Cold Press. The cold-press papers are a medium

sort, neither rough nor smooth. They come in various types, too. Some are heavily sized, so that the paint stays on the surface; others have less sizing and are therefore more absorptive. I like Arches cold-press paper, especially the 140-1b, 260-lb, and 300-lb weights. Occasionally, I also use the 140-1b rough. All these papers can take a good beating. In Figure 2, for example, you can see how I prepare a paper for corrections. In this case, I've sponged out all but the left-hand corner. Notice, however, that a lot of dark lines remain in Figure 3. The lines show

where I scraped branches into the paper with the end of my brush. I damaged the surface of the paper and will never be able to get those marks out. That's one reason you should refrain from scraping till you're sure your composition is *right*.

Rice Paper. I don't like rice paper. It softens lines and automatically harmonizes your picture, but the effects are far too accidental. I want to be in control when I work—and with rice paper everything depends on chance. I feel as if the paper is using me, instead of my using it!

FIGURE 1. *(Above) Make corrections on glass first— you can see how they'll look without damaging your paper.*

FIGURE 2. *(Top right) I disliked all but the left side of this picture, so decided to sponge it clean.*

FIGURE 3. *(Right) Water applied with a natural sponge eliminated most of the painting; the dark lines show where I damaged the paper by scraping it with the end of my brush.*

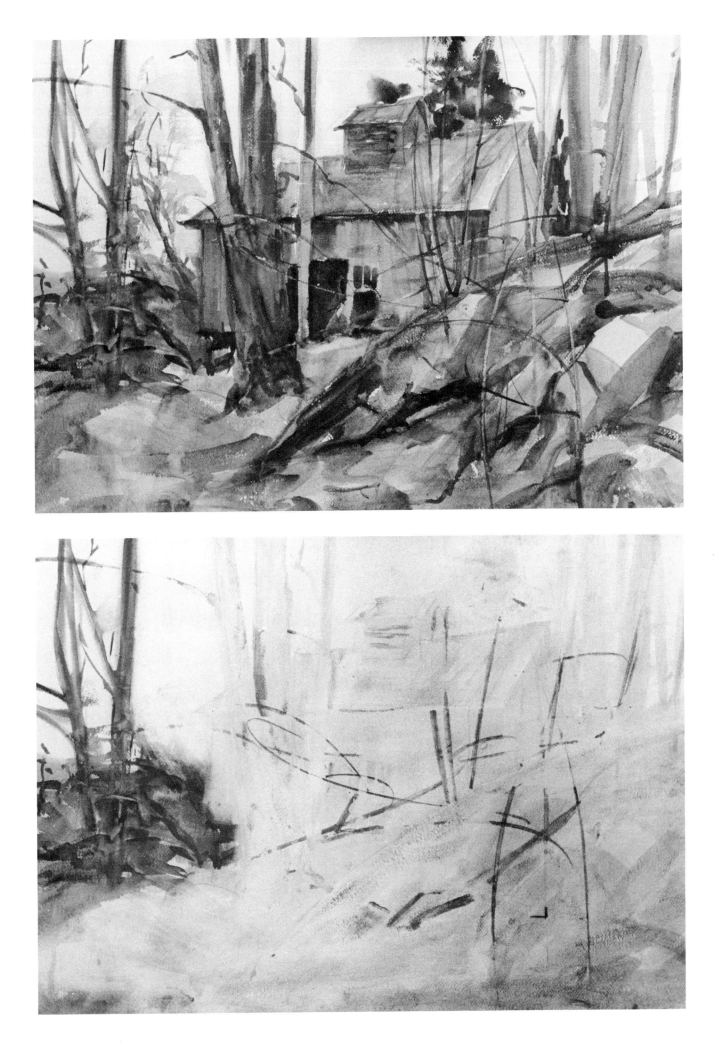

Palette

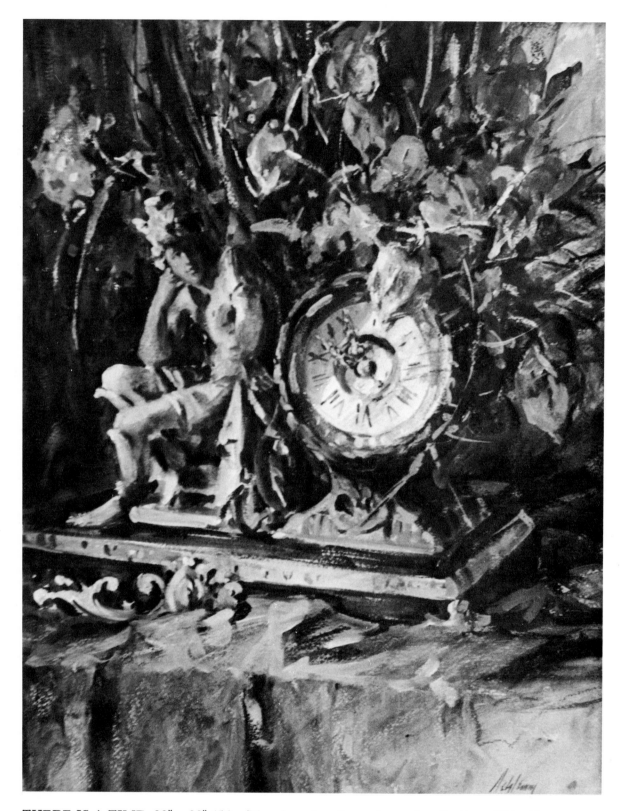

THERE IS A TIME, 22" x 30" (56 x 76 cm), watercolor and pastel, collection of Lisa Franco. *When pastel and watercolor are used together, as in this picture, it's important that one or the other predominate and that the pastel is never used simply to "fix" an isolated area. Here I planned my lights carefully and then used the pastel to model the areas out of the light. The pastel quiets these parts and makes the highlights stand out in contrast. Since pastel is never as bright as watercolor, I don't use the pastel to claim highlights that were accidentally lost while painting. The pastel's job is to add strength and solidity to the darks—a strength that corresponds to the character of the clock and its military decorations.*

When I started to paint in watercolor, every space on my palette was filled. Since that time, I've steadily simplified my choice of colors. If one pigment can do the work of two or three, then that's the one I use. I now feel that my palette is reduced to the absolute minimum. Yet there's nothing sacred about these colors. If they all went off the market tomorrow, I could develop another workable set. So try my palette—but don't be afraid to experiment outside it.

QUALITY OF COLOR.

I use "AA" or "A" grade paints—colors that have been carefully tested for permanency. I buy *tubes*, not cakes of color. Since I like to be able to make corrections, I try to avoid the dye colors. They're transparent and clean—but very hard to remove from the paper. As you saw in the first chapter, all my colors can be sponged off the paper—cadmium yellow is the only one that gives me trouble.

OPAQUE COLORS.

When discussing my colors in more detail, I'll mention which are opaque and which transparent. As their name suggests, opaque colors lack transparency when used heavily in a wash. Sometimes such opaque spots add to a painting; a little opacity accents the transparency of the other washes. But as a general rule, I use a lot of water when working with opaque colors. That way, I can always feel the paper through the wash.

If I'm so interested in transparency, why don't I drop all the opaque colors? It could be done. But I like to mix transparent and opaque colors together. The heavy colors settle, the washes break up, and the result—as we'll see later in the demonstrations—is an interesting "broken color" look. Paint and water can do beautiful things—if you just leave them alone!

ARRANGEMENT OF THE PALETTE.

Figure 4 shows how I set up my palette. The colors move from the lighter to the darker colors, with my most brilliant colors on the top and my earth colors (the browns) on the bottom. The colors on the top also move from warm to cool.

The "warm" colors are the colors you associate with the sun. The sun is yellow—and the warm colors are therefore yellow and its relatives: orange and red. In the shadows, you naturally feel quiet—and "cool." The cool colors are the various forms of blue. Green is an in-between color; it can be either warm (yellow-green) or cool (blue-green). Of course, some warm colors are "cooler" than others, and a blue may be "warmer" than its neighbor. In Figure 4, for example, both colors 1 and 5 are warm—but 5 is duller and "cooler." Similarly, both 6 and 8 are cool, but 6 is brighter and "warmer."

The related colors are grouped together on the palette; one color can spill into its neighbor without hurting it. The blues are also together—as are the similarly colored yellow ochre and raw sienna, and

the burnt sienna and light red. Spaces separate each group of colors. The corners are empty. When I use the palette, I angle it so the water runs out the lower right-hand corner. The palette thus becomes self-cleaning, and I don't have to worry about dirtying my brilliant reds and blues.

THE COLORS.

I use the following colors in my palette:

1. Lemon Yellow (opaque) is a soft color, especially useful when mixing nature's quieter greens.

2. Cadmium Yellow Deep (opaque) is a much more brilliant, forceful yellow. It's strong and lively—so strong that I always use it with a lot of water. It's probably the most opaque of all my colors. When you use it, make sure you change water frequently. Its sediment accumulates in the water and can dirty later washes.

3. Cadmium Orange (opaque) is one of the colors I could drop from my palette; it can be mixed with cadmium yellow deep and cadmium scarlet. But it's convenient to have, especially when I'm painting flowers and want clarity of color. If you're economizing, don't bother to buy it.

4. Cadmium Scarlet (opaque) is a very warm color. It mixes beautifully with my other pigments and, to me, has a look that's reminiscent of nature.

5. Alizarin Crimson (transparent) is a clean color, useful when painting dark areas. It makes lovely grays—and a beautiful pink when mixed with lemon yellow. Alizarin crimson is a dye color, but it can be sponged off the paper if necessary.

6. Cerulean Blue (opaque) is a quiet, warm blue.

7. Cobalt Blue (semi-transparent) is the coldest color on the palette. It mixes well with the other blues. It makes good grays, is useful in dark areas, and works well in skies—in short, it's a color all watercolorists like.

8. Ultramarine Blue (transparent) is a dark, warm, reddish blue. I usually reserve it for the end of a painting, when I want to give the composition some extra punch.

9. Yellow Ochre (opaque) is a quiet color, good both in grays and for softening other colors. It's also useful when painting greens, sand color, rocks, and so forth.

10. Raw Sienna (transparent) is an essential color. It's the strongest transparent warm color we have—just as cobalt is our coolest blue. We need the two extremes—the warmest and coldest—to influence all the other colors on the palette. In times of a paint shortage, art supply stores always sell out cobalt blue and raw sienna first. Everybody likes them.

11. Winsor Green (transparent) is a powerful dye color. I sometimes think you can get an effect by

simply looking at it! You can see how it's isolated on the palette. It's a strong green—and I never use it by itself. Being neither warm nor cold, it can be tipped one way or the other by the colors around it. Add raw sienna, for example, and you get a warm, light green. Add burnt sienna, and you get a warm, dark green.

12. Burnt Sienna (transparent) mixes well with all the other colors. It makes good darks and also warms up darker pigments. Alizarin crimson, for example, can often be too cold by itself. A touch of burnt sienna picks up the color.

13. Light Red (opaque) is a very old, very safe color. It grays beautifully when mixed with blues— without damaging the quality of those colors. It's a heavy, opaque color and breaks up nicely in a wash. When mixed with cerulean blue, for example, it goes on as a gray wash, but soon separates, creating areas of broken color.

14. Chinese White is used for corrections. It's not on my diagram, because I add it to the palette only when it's needed for *immediate use*. I put it in the empty space next to the lemon yellow—and remove it as soon as I'm finished with it. Leave it on the palette, and it gets into everything, deadening all your color.

15. Black is also missing from my palette. I once used the popular Payne's gray. But I can still remember Norman Kent pointing to parts of my work exclaiming "Payne's gray! Payne's gray!" He could see the color in all my mixes. It was *too* convenient. I'd use it whenever I needed a gray—

without looking for the special quality that distinguishes one gray from all the others. I've since learned that, thanks to light, even grays have character!

The four colors I use for mixing "black" are alizarin crimson, Winsor green, ultramarine blue, and burnt sienna. Since you should always be able to see into your darks—that gives them life and air—I make sure that all four of these dark colors are *transparent*. I don't want an opaque black. I usually vary my darks by mixing any three of these colors, with one predominating. Winsor green and alizarin crimson, for example, make a black right on the nose. A touch of burnt sienna adds variety to it. Winsor green and ultramarine blue also make a good dark—alizarin can be added to give it extra life. Never mix all four colors together. They'd be flat and nondescript—like sepia or India ink. Remember: where there's light, there's color!

SPECIAL COLORS. Special situations call for special pigments. When I'm doing flowers, for example, and want pure, clean, intense color, I add cobalt violet (warm, light, and very opaque) and Winsor violet (cool, dark, and very transparent) to the palette.

Different kinds of light also call for new colors. My present palette is well suited for working in New England. When I went out West, however, the clear, harsh light made me add manganese blue and Naples yellow—they helped me express my feeling for the locale. That's why it's wise to experiment with your palette. You may discover something that will help you grow as a painter.

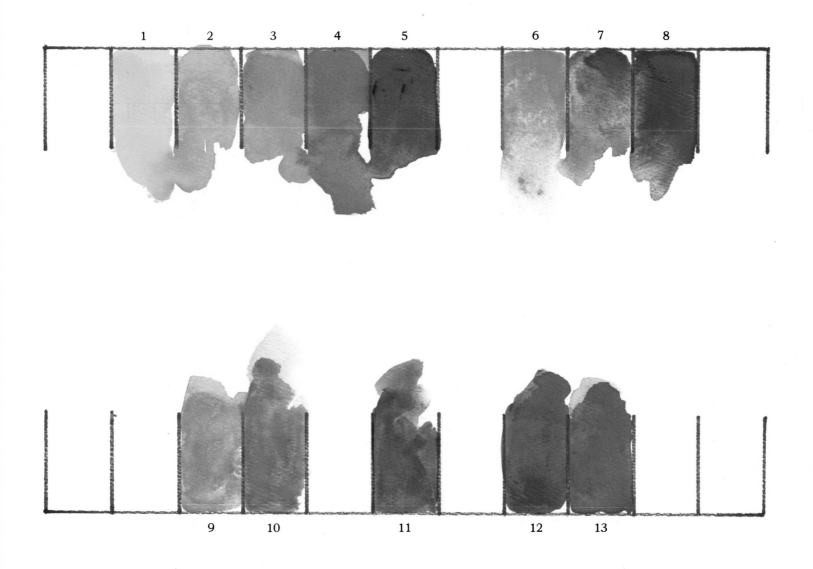

FIGURE 4. *My palette.*

1. Lemon Yellow
2. Cadmium Yellow Deep
3. Cadmium Orange
4. Cadmium Scarlet
5. Alizarin Crimson
6. Cerulean Blue
7. Cobalt Blue
8. Ultramarine Blue
9. Yellow Ochre
10. Raw Sienna
11. Winsor Green
12. Burnt Sienna
13. Light Red

Light

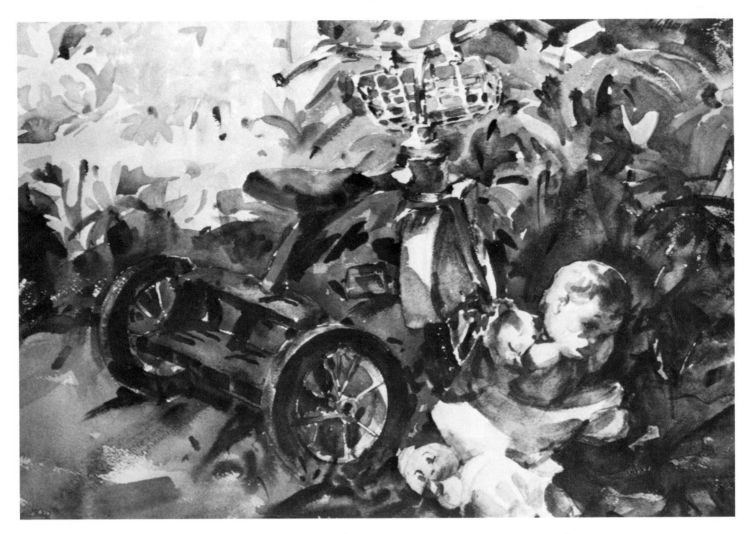

JENNIFER'S BICYCLE, *15" x 22" (38 x 56 cm), collection of Jennifer Franco.*
I painted this picture after my niece, who'd spent a week with me, had left for
her home in another state. I tried to take advantage of the expressive use of
shadow by placing the toys in the darkened part of the yard. I want them to
seem discarded. They're no longer used—and the feeling of activity has now
shifted to the sunlit distance. Where there's light, there's life.

Light is the life of a painting. After years of painting outdoors, I've come to certain conclusions about how light behaves. I'll first discuss my general ideas about light and then, in the chapters that follow, describe the way it relates to my use of key and watercolor washes. We'll then proceed to a sample demonstration and see how my ideas are applied to a number of practical problems.

SOURCE OF LIGHT.
Traditional painters usually look at light in one of two ways. They prefer either what I call a "one-source light" or a "two-source light." To help you understand the basis for my approach to light, I'd like to compare these two approaches.

One-Source Light. We have an example of a one-source light when a spotlight is placed very close to a still-life, so close that the color of the bulb dominates the setup. The areas not struck by this light are dark and nearly colorless. They tend toward black. These deep, almost impenetrable darks are what give both form and drama to paintings done in the one-source manner.

As areas of an object move away from this single, strong source of light, you darken the shadows by touching it with its complement. If the object is green, for example, you add red to the areas that move away from the light. If it's yellow, you add purple; if blue, you add orange. And *vice versa* in all three cases. The complement darkens and grays a color without changing that color's basic character. You may sometimes have to use a brown or dark blue to darken an object before adding the complement. If the object is purple, for example, adding the complementary yellow (a color high in value) as it moved from the light would lighten the color rather than darken it. You'd have to darken the object first—and then add the complement so you can *feel* it in the areas away from the source of light.

Such cases are special, and practice with the medium will teach you how to handle them. The point I want to emphasize is that by using complements you do not change the *character* of your color. And that keeps you from making a mistake often seen in student work: the apple painted red on the lighted side and brown on the dark side. Such an apple looks as if it were made of two different materials!

In Figure 5, I painted an apple using a one-source light. The spotlight is close to the object. Because the right side of the apple is nearest the light source, the bulb's warm, yellow-orange color affects the apple's shiny surface. As the round form of the apple turns from the light, I add green—the complement of the red in the apple. You can't *see* the complement in the mix, but it turns the red almost black. The result is a very solid, sculptural form. Rembrandt used this kind of light, as did Winslow Homer in many of his watercolors.

Two-Source Light. If you move the spotlight away from the still-life, the source of light naturally has a less powerful effect. There's still a clear *value* difference between those areas hit by the light and those out of the light. But now there's also a *color* difference. The farther away the light is, the more obvious these differences. And it's this color that I find so interesting and exciting. Where does it come from?

Those areas hit by the spotlight—what I call the "main light"—are still warm, just as in a one-source light. But the areas in darkness are now affected by the color of the rest of the room—what I call the "allover (or overall) light." These are the two main parts of a two-source light: the main light and the allover light. In a room, this allover light can be a fairly complex mixture of colors. Part of it may come from an incandescent or fluorescent lamp in a corner; part will come from the color of the walls and the woodwork; part will come from

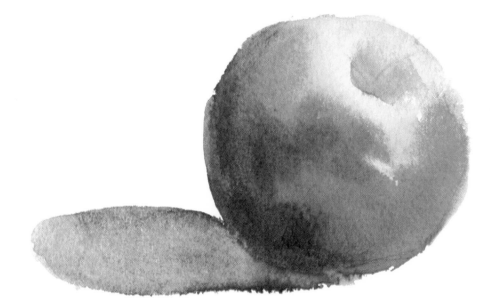

FIGURE 5. *One-source light: Although light colors the areas nearest to it, the shadows all go quickly to black.*

the color of the outdoors as it streams in through a door or window. In nature, the situation is a bit more straightforward. The main light comes from the sun and is usually warm, while the allover light comes from the rest of the sky and is usually cool. We'll soon explore these relationships more fully.

In the one-source light, we darkened an object by adding its complement. We still do this when using the two-source light. In addition, however, an area moving away from the source of light also begins to take on the complementary color *of that light*. The farther a part of an object is from the light, the more obvious the complementary color becomes. In art school, for example, I can remember an exercise in which the instructor turned a red spotlight on the model; the shadows on her body all went green! If he'd used a green light, the shadows would all have been very red. If he'd moved the spotlight very near the model, however, the light would have been overpowering and, as before, the darks would simply have gone to black. The green showed with particular clarity because the walls of the studio were relatively neutral in color. Theoretically, these walls provided the allover light in the room, but they weren't colorful enough to affect the dark areas.

In Figure 6, on the other hand, the strong allover light is mainly coming from the blue sky as it enters the room through a nearby window. Using the same standard yellow-orange bulb to illuminate the apple, I move the spotlight back so other light can affect the darks. I then add the complement (green) to dull the apple in the area less strongly influenced by the light. I also add some blue to the dark area—a blue that is complementary to the light. And on the far left side of the apple, I show the strong influence of the cool allover light from the window.

Remember, now, that if I'd used a blue bulb on this same apple, the area hit by the main light would be cool rather than warm; the area hit by the overall light would still be cool; but the dark area in between would be slightly warmer in color—it would show the influence of the orange complement of the light. I'd like to be able to tell you why this complementary color appears where it does, but I can't. I've observed it, without having explored the physics of the phenomenon. If you have different color bulbs at home, however, you may want to experiment with this fact and prove it to yourself.

While less dramatic than Figure 5, Figure 6 looks more natural to the eye; you feel that the form exists in light and air. And in the following discussion and demonstrations, we'll see how this idea can also be applied to landscape painting. In fact, it's in landscape painting that it's received its finest expression. The Impressionists—all outdoor painters—were the first to make a careful study of the interesting visual effects created by a two-source light. The results of their investigations can be seen with particular beauty in the work of two of the greatest students of light: John Singer Sargent and Joaquín Sorolla y Bastida. You can read textbooks about color, if you want—but you'd do better to study the work of these two masters.

THE INFLUENCES OF LIGHT. As you can tell, I prefer the two-source view of light; and that's the approach we'll explore in this book. In order to make it easier to talk about light, I have decided, rather arbitrarily, to list nine ways that light influences objects. These are my own categories, the result of many years of outdoor painting. Of course, there aren't nine neat categories in nature. The effects of light are all inter-related, like the fingers of two hands clasped tightly together. Trying to isolate each element is very difficult. If you find my exposition confusing at times, the best solution would probably be for you to continue reading till

FIGURE 6. *Two-source light: Light colors the areas nearest to it; color from the surrounding areas creeps into the parts of the apple not struck by the main source of light.*

FIGURE 7. *Trees are hit by the warm source of light.*

you've begun to get a sense of the categories *as a whole*. You'll then be better able to relate one to the other.

I should also note that I don't expect every visual phenomenon to fit somewhere under my headings. There are no absolutes in light; like people, light can do funny things. I just want to show you a few fundamental ideas, ideas based not on an abstract theory but on the way nature actually behaves. Don't memorize these influences. They're not a way to pigeonhole nature. On the contrary, they should make you close this book, open your front door, and take your *own* look at the world. I'm suggesting things to look for; you'll have to make the big discoveries on your own.

THE TWO PRINCIPAL SOURCES OF LIGHT.

The basic light on a subject comes from two sources: the main light and the allover light.

The Main Light. I use the term *in light* to describe those areas which are most directly influenced by the light from the sun or from a bulb. On the average sunny day—to use a particularly obvious example—areas hit by the warm sun naturally take on a warm coloration. In Figure 7, for example, you can see the warmth of all the surfaces facing the sun: the warm foliage, the warm earth, the warm roof of the house. Since nothing is as brilliant as the white paper, I let it stand for the house in light. I'd only dull it by trying to glaze over the area with a warm color.

The Allover Light. The part of an object not hit directly by the main light takes on the color of its surroundings—the allover light. On a clear day, for example, the color of the sky is the allover light. In Figure 8, the vertical white buildings in the distance get a direct and brilliant blast of light; the horizontal plane of the snow in the foreground,

FIGURE 8. *The foreground snow is influenced by the allover light.*

however, can't catch such a direct light—so it's colored by the sky overhead. Being white, snow shows the effect of these surrounding colors with particular clarity. But the overall light can also be seen and felt when it touches the tops of trees, grass, rocks, the roofs of houses—everything that isn't *directly* affected by the main light.

MOVING AND TURNING FROM THE LIGHT.

Now that we've discussed the two basic sources of light, we can look at the effect the light has on objects moving in space.

Moving Away in the Light. Although sunlight is distributed evenly over the landscape, wherever you happen to be standing usually appears to be the spot where the sun is shining most strongly. In a landscape, the dust and moisture in the air accumulate to form what the great painter and teacher John F. Carlson calls the "veils of atmosphere"—the cause of what is commonly known as "atmospheric perspective." The material in the air prevents the color of distant objects from coming to us in their full intensity.

You've seen how objects, as they move away from you, gradually appear to become duller in color. They tend toward a neutral; that is, warmly colored objects become slightly cooler in color, while cool objects become slightly warmer. In this interaction, the warm and cool colors eventually cancel each other out, so that the farther back in space an object is located, the less color you can see in it. Each color holds its identity to a different degree. Yellow loses its identity very quickly; white remains white for quite a long time. But no matter how far back in the landscape a sunlit object is, or how much its color identity is lost, it always appears to be influenced by the sun.

A somewhat similar effect can be seen within the geography of a still-life. Since the light is concentrated on a limited area, you can see more clearly how its strength lessens as objects move away from it. In Figure 9, for example, the spotlight is aimed toward the two bottles. As a result, the background cloth between them receives a strong blast of warm light. As the cloth moves to the right and the left, it's still in the light, but the strength of the light naturally diminishes. The color becomes duller and more neutral; in this case, it becomes slightly cooler.

Turning from the Light. When I talk about an object moving away in the light, I refer to both (1) the amount of atmosphere between the viewer and the sunlit object and (2) the distance between the source of light (a spotlight) and the object it influences. In both cases, I'm concerned about the spatial positions of objects directly affected by the main light. The term *turning from the light*, on the other hand, is applicable primarily to curved surfaces exposed to a raking light, rather than a direct one.

As I noted earlier, the complements (1) of the light and (2) of the color of the object *both* begin to have an influence as an object moves away from the main light. The effect increases as the object *turns* from the light. As our apple turned from the light, for example, it began to get (1) slightly darker in value since it was no longer strongly illuminated; (2) slightly grayer, since the red naturally became duller (green was added to the mix); and (3) slightly cooler, as the warmth of the light began to lose some of its force. Such an area, however, *never* becomes as dark as the part of the object entirely out of the light. If you painted it that dark, you'd destroy the basic light-dark divisions of your picture—and, thus, the truth of your statement. Remember: areas influenced by the main light must always look as if they're influenced by this light, just as areas not influenced by the light must always appear to be out of the light. That's why an object, as it turns from the sun, may become cooler, but it will never cross the line that separates warm from cold color. As soon as it becomes cold, it ceases to be an area influenced by sunlight.

In Figure 10, for example, the rounded parts of the hills in the foreground, middle distance, and distance all turn slowly away from the light. The sun hits them at an angle. Pay particular attention to the green field in the center of the picture. Where the field is struck directly by the main light, it's quite warm; but even the areas curving away from the light have a lot of warmth and color in them.

Out of the Light. Once an object has completely turned from the main source of light, it is, of course, out of the light. The main source of light cannot hit it directly. The area is therefore duller and darker than the part of the object in light; it also shows, most strongly, the influence of the complementary color of that light. In Figure 11, the house on the right is in light; the one on the left is clearly out of the light—that is, it's at such an angle to the sun that sunlight cannot touch it directly. As we've already noted, this side would naturally show some cool color—the color complementary to that of the main light. In this case, the effect is exaggerated by the fact that the house also catches a lot of cool color from the overall light of the surrounding sky.

I should note that under normal conditions, the out-of-light side of a white house is always darker than the sky. Many students have trouble with this fact; they *know* how white the house is, and they want it to look white, even when it's not hit by the sun. The coolest out-of-light edge is usually found nearest to us at the point where the in-light and out-of-light sides of the house meet.

Figure 12 shows a different sort of out-of-light spot—the sheltered place under a wharf. It's like looking into the inside of a barn or through the door of a house. Although light has trouble getting into it, the space is far from pitch black. There's air

FIGURE 9. *The background drapery moves from the source of light.*

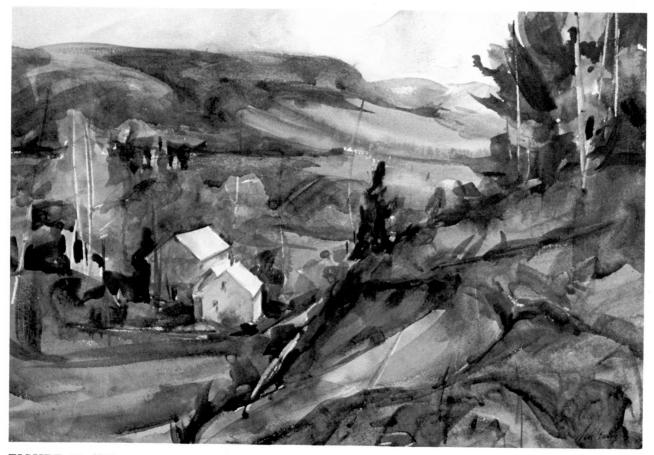

FIGURE 10. *Hills turn away from the source of light.*

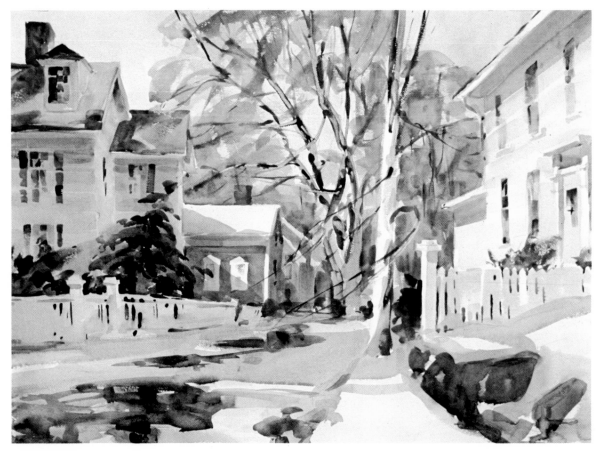

FIGURE 11. *The house on the right is in light; that on the left, out of the light.*

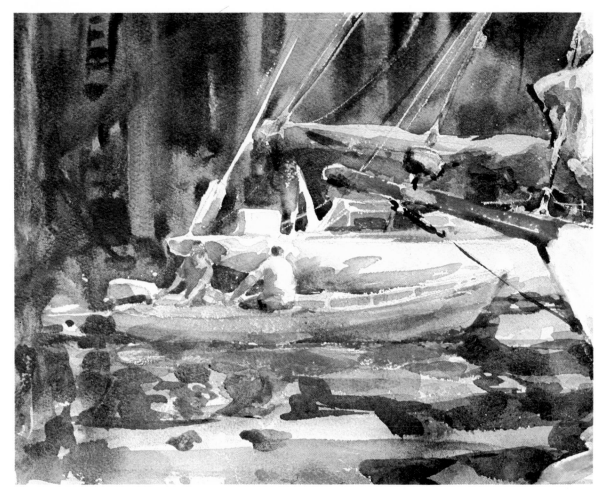

FIGURE 12. *The sheltered area under a wharf is out of the light.*

in it, and you can see *into* the darks. They're transparent. Since there's little light to create value contrasts, the edges are soft, quiet, and mysterious.

ADDITIONAL CONSIDERATIONS.
If you've looked closely at the previous illustrations, you've probably noticed colors that can't be explained by a simple reference to the influences of either the main light source or the allover light. Much of this additional color is the result of:

Reflected Light. When light hits an object, it bounces off it, sending color into surrounding areas. When the object is shiny but relatively colorless—like the ocean—it merely acts as a mirror and reflects the color of the sources of light. In order for one object to reflect light into another, however, it's not at all necessary that either be particularly shiny. If you wear a red wool shirt, red light from that shirt will bounce up under your chin: the warm color will be clearly visible. Similarly, light hitting grass and foliage will send warm green color into the in-light and out-of-light areas of a house. Nature is full of such examples.

Depending on the nature of the day, reflected light can be either a very important part of your picture—or a quite negligible one. The strong light of a clear day, for example, reflects color into everything. At a beach, the brilliant sun bounces light off the sand into the surrounding darks, obliterating them. On a very dull day, however, such effects are more subtle; the reflected light is much harder to see.

The same principle applies to work done indoors. The color reflected into a still-life from the walls of the room is really a form of reflected light. If there is no strong secondary source of illumination—like the blue sky pouring in through a north window—then the reflected light of the studio walls can, in fact, become your allover light.

Generally speaking, objects have to be fairly near one another for the reflected light to have an effect. In Figure 13, for example, the green bottle, while strongly colored itself, also shows the color reflected into it from the nearby red apples and from the orange background drapery. The color of these red-orange accessories is so strong that it even reflects down onto the top of the white cloth on the table. Neither the cloth nor the accessories are "shiny"—but you can still see the effect of the reflected light. The white cloth escapes this influence only when it turns from the light and drops over the edge of the table. In that position, it's impossible for the red-orange color to reach it.

Cast Shadows. We've seen how reflected light can warm both the in-light and out-of-light parts of an object. A cast shadow, on the other hand, tends to block out reflected warm light and thus creates some of the coolest areas in our picture. While an out-of-light area can have a lot of warmth in it, a cast shadow can only go from a cool to a neutral

gray. It can *never* be warm, for it then ceases to be a cast shadow.

The amount of color you see in a cast shadow depends on three main factors:

1. The *closeness* of the objects casting and receiving the shadow. This is the primary relationship. The nearer the objects are to one another, the less chance sunlight has to creep between them. The cast shadows thus become dark and cool.

2. The *intensity* of the light. If it's a bright, clear day, the shadows will be darker and more colorful than on a hazy or dull day. The complementary color of the light will be more clearly seen in them.

3. The *nearness* to us of the objects and their cast shadows. If a tree is next to us and the shadow runs directly in front of our feet, that shadow will be darker, cooler, more colorful, more luminous, and more hard-edged than a shadow cast by a similar tree some hundred feet (33 meters) down the road. Atmospheric perspective dulls the color of the distant shadow and softens its edges. The dust and moisture in the air also have the same effect on background shadows as they have on distant in-light areas; they pull the shadows together so that they all read as the same basic color.

When I paint cast shadows, I use a fairly simple procedure. I start with the premise that cast shadows are all the same color: the complement of the light. How strong this color is depends, again, on the intensity of the light. I don't paint my cast shadows till the picture is almost done. I then take the shadow color and lay it on the paper in a transparent glaze. Since the shadows are glazed, you always feel the color of the first washes beneath them. You sense the materials that the shadow is covering.

In the distance, I use extra water to dull the color. In the immediate foreground, I may enliven the shadow by adding extra color. If the shadow falls on a yellowish dirt road, for example, I'll add a bit more of the road's warm color. If it falls on grass, I may add a little extra green. Remember: the shadows never become warm! And they always retain their own shadow color. The color *beneath* them is what changes as the shadows run over grass, up a stone wall, and across a street.

In Figure 14, you can see cast shadows on the house, the trees, and the foreground road. Notice particularly the warmth of the glazed shadow in the lower right-hand corner. You can feel the color of the road coming through the shadow, though the shadow remains cool.

In Figure 15, the shadows on the bridge are cast by distant objects. The shadows are therefore light in value and soft-edged. In the background, however, a grove of trees casts very dark shadows on the green bank. The foliage of these trees acts as an umbrella and prevents light from working its way into the shadows. They remain dark and cold.

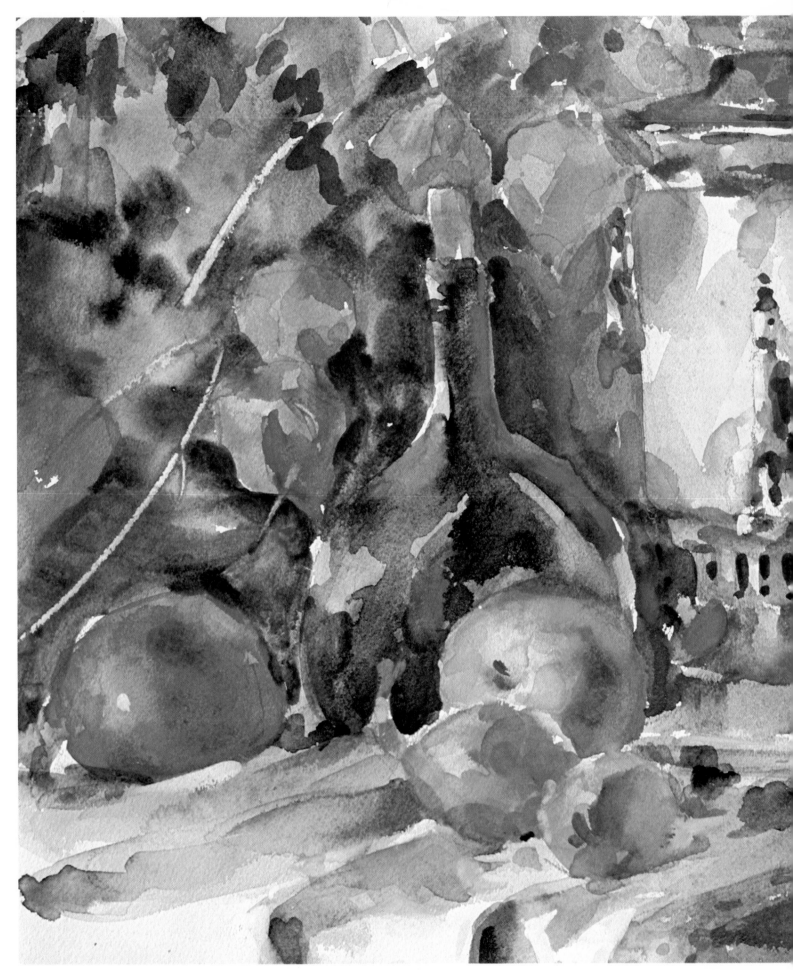

FIGURE 13. *The bottle catches reflected light from a variety of directions.*

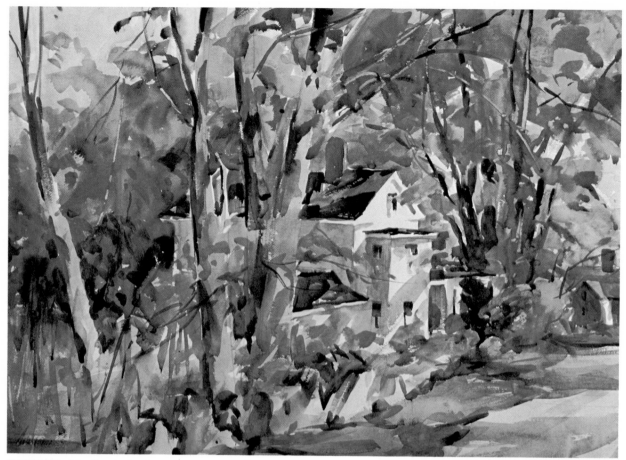

FIGURE 14. *Cast shadows appear on the road, house, and trees.*

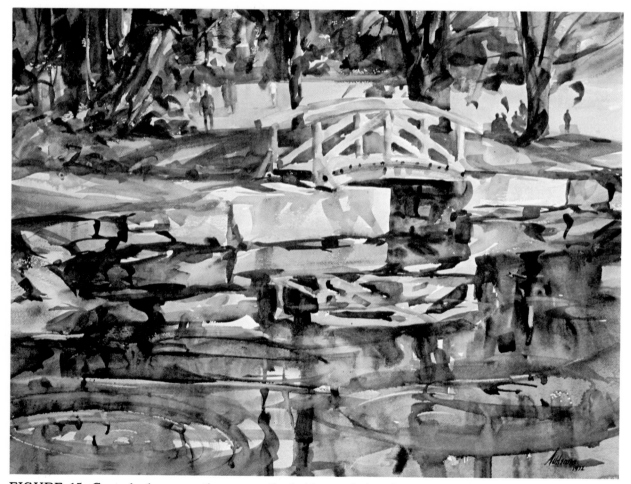

FIGURE 15. *Cast shadows are thrown on the bridge and the distant grass.*

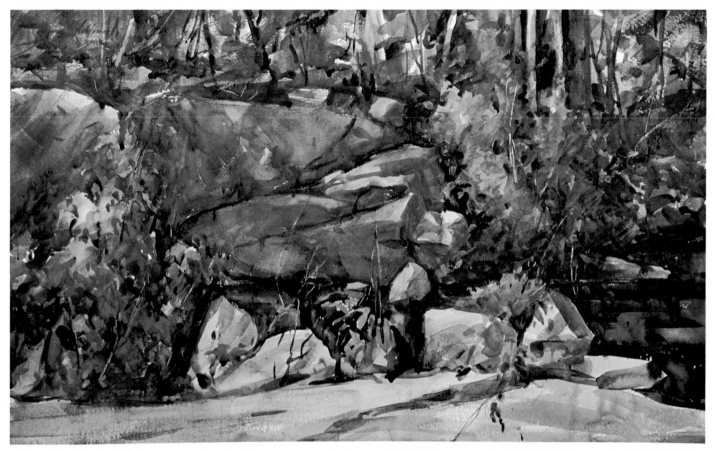

FIGURE 16. *No-light areas appear in the crevices of the rock and under the nearby bushes.*

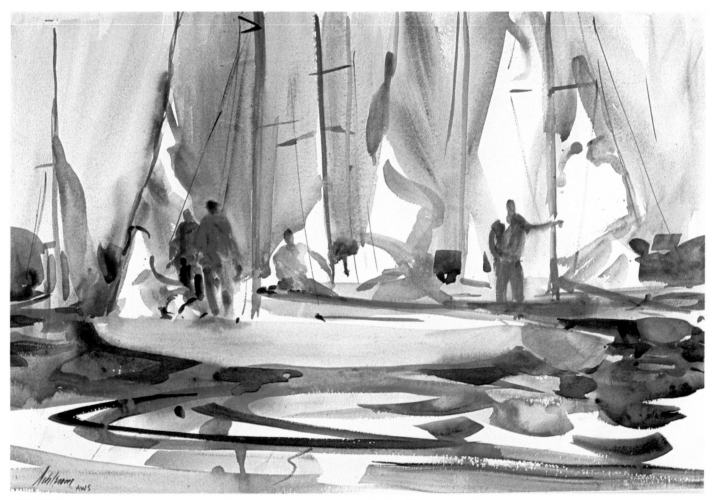

FIGURE 17. *Light comes through the semi-transparent sails. (Collection of Virginia Carton)*

No Light. When objects are very close together, the spaces between them are unaffected by the source of light, the allover light, or any reflected light. I call such spaces "no-light" areas. In Figure 16, for example, the crevices between the rocks and the small dark spots under the nearby bushes are no-light places. Notice the difference between the no-light spots and both the cast shadows and the areas out of the light. The latter have luminosity and color in them; the no-light areas are cold, dark in value, and relatively colorless.

Translucency. Light coming through a translucent or semi-transparent material is darker in value than direct light, but still very intense and warm. It's a beautiful kind of light. In Figure 17, for example, you can see this warm light filtering through the sails. In Figure 18, the flower on the left is past its prime. Like the sails, the thin, delicate surface of the decayed petal also lets the intense warm sunlight shine through it.

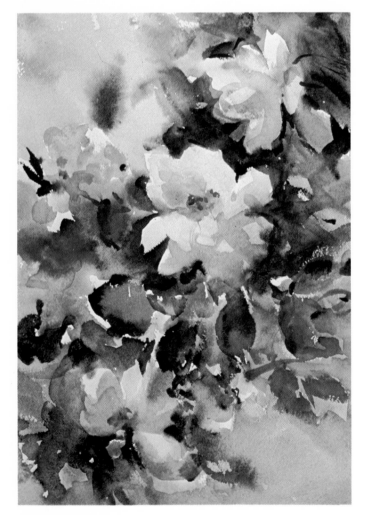

FIGURE 18. *Light comes through the petals of the flower on the far left. (Collection of Genevieve Wilhelm)*

A SPECIAL CASE: THE GRAY DAY. The gray day presents a particularly interesting and elusive light problem, and I'll end our discussion of the influences of light by taking a few minutes to talk about it.

On a gray day, we have what could loosely be called a one-source light. The clouds diffuse the light of the sun so that we have a single allover light. This light radiates *down* from the sky, striking mainly horizontal and slanting planes.

To understand what happens on a gray day, let's think, for a minute, about light on a bright, hazy day. On such a day, the moisture in the air affects the sunlight exactly as it affects distant sunlit objects (atmospheric perspective). In passing through the heavy atmosphere, the light becomes duller. It loses some of its intensity; that is, the light actually becomes slightly cooler in color. The difference is very subtle, however, and you still have a strong sense of the sun's warmth.

This effect is greatly exaggerated on a gray day. The clouds and moisture become so heavy that (1) the sunlight is diffused throughout the sky and (2) the light, dulled by the moisture, becomes not only cooler—it actually becomes *cool*. I'm not saying it's ice cold, but it passes over the line that separates warm from cool color. I've often observed this phenomenon—but will let the physicists and meteorologists give you a more "scientific" explanation for it.

To further understand this light, let's look at its effect on a white house. Strictly speaking, a white house on a gray day is out of the light. It's a mass, all sides of which are darker than the sky. In fact, however, one of these sides is usually cooler than the other: that side nearest to the area of the sky hiding the sun. The other side of the house is slightly warmer, following our general rule that an area not influenced by the dominant light will take on the color complementary to that light. Now, one side of the house isn't blue and the other orange! One side is simply *warmer*—perhaps by only a hair—than the side influenced by the cool light of the day.

You can see this gray-day effect in Figure 19. The foreground rocks receive a lot of cool color from the allover light of the sky. In fact, you can clearly see touches of blue here and there. The darker areas, on the other hand, are warm in character. Notice also the small building at the far end of the pier. The front of the building is influenced by the hidden sun. As a result, the front is cool. The opposite side, however, is warm in color. These differences are subtle, but they *must* be noted if you want to capture the feeling of a gray day.

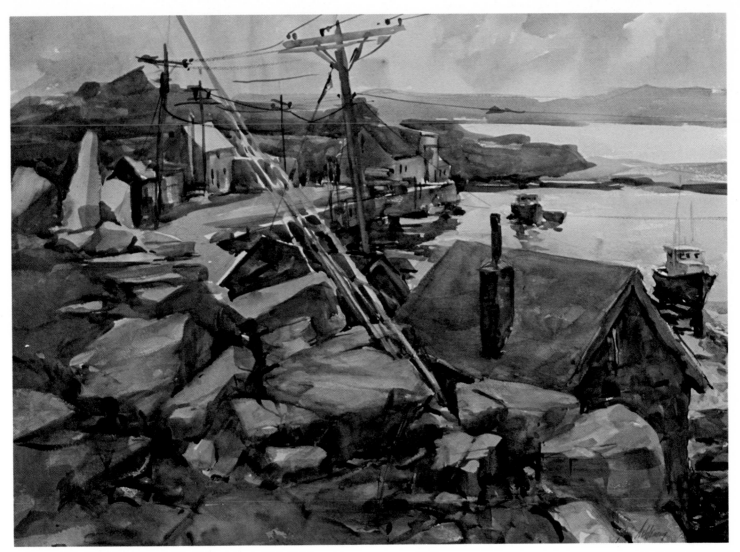

FIGURE 19. *To capture the effect of a gray day, you must pay close attention to subtle changes in cool and warm lighting.*

Mood

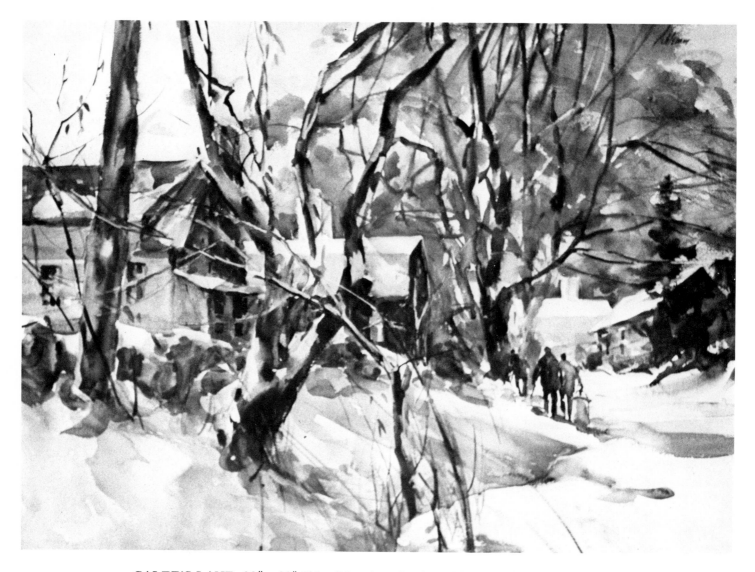

CALEB'S LANE, 22" x 30" (56 x 76 cm), collection of Louise Toomey. In this picture, I wanted to emphasize the cold, blustery nature of a Rockport winter. I tried to suggest the force of the wind by angling the foreground saplings. They move diagonally, paralleling the shape of the large, windblown snowdrifts. These saplings didn't angle as forcefully on the spot; I simply seized on an aspect of their movement and exaggerated it for expressive effect. Notice that the children are tied in with the trees and the shadows of the snow. Their clothing is also dull in color—so they become part of the whole scene. They're not my subject. Although I finished the picture in the studio, I began it on the spot. It's essential to feel cold in order to paint it convincingly.

Now that we've discussed certain basic effects of light, let's take a minute to talk about the elements of a painting that are most closely related to these basic light effects: the key of the picture, the character of edges, and the use of various washes.

KEY. One of the major ways light creates mood in a painting is through key. How, for example, will the lights and darks be distributed in a picture? Which will predominate? And how will the key relate to the character of the subject?

You may find key easier to understand if you compare the basic black-and-white value scale (Figure 20) to the keyboard of a piano. The 50% value is at the center of the scale—what we'll call middle C in our piano analogy. In any given picture, a certain amount of color will be low in value (below middle C). Such color is like the deep, sonorous notes of the piano. A certain amount of color will also be high in value (above middle C). Such color is like the brilliant notes of the piano's upper register.

Now the values in a picture actually affect our eyes very much like musical notes affect our ears. If there is a predominance of darks in a picture, for example, the picture is said to be low in key. And the darks usually create a brooding, sober, dramatic feeling—just as would a piece of music similarly full of deep notes. If there are a lot of brilliant whites and light grays in a picture, the picture is said to be high in key. The effect on the viewer is usually a happy one—just like the effect of a piece of music played in the piano's bright upper register.

What is uninteresting, both in painting and music, is a composition in which the notes all cluster around middle C or in which there are exactly as many low notes as high ones. There's no dominant idea in such work. And looking at it is the visual equivalent of listening to idle chatter at a party—where pleasantries are passed without anything really being said!

Directing the Eye through Values. You can direct the viewer's eye by the way you distribute your darks, lights, and midtones. If the darks and midtones cluster below middle C, with only a few lights far above middle C or 50% mark, then the greatest interval is between the midtones and the lights. The result is that the lights pop. The viewer sees them first. I've illustrated this effect in Figure 21. Because the sky, trees, ground, and out-of-light darks are all close in value, you're therefore struck by the brilliant white of the sunlit house.

If, on the other hand, there are only a few deep accents in your picture, while the lights and midtones are all clustered above middle C, then the greatest interval is between the midtones and the darks—and so the darks pop. In Figure 22, the dark ground, roof, and trees stand out against the light, close values of the houses and the sky.

FIGURE 20. *The value scale is graduated in easy steps from black to white.*

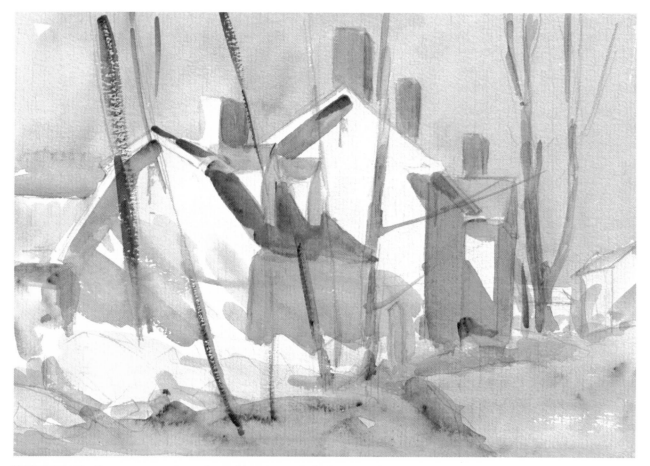

FIGURE 21. *On a sunny day, the midtones and darks are close together, while the whites are high on the scale—you therefore see the whites first.*

FIGURE 22. *On a gray day, the lights and midtones are clustered together, while the darks are low on the scale—you therefore see the darks first.*

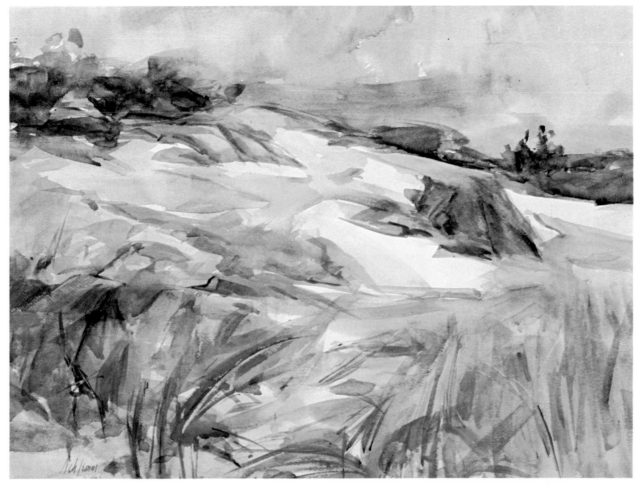

FIGURE 23. *A high-key picture: the lack of contrasts matches the quiet nature of the scene.*

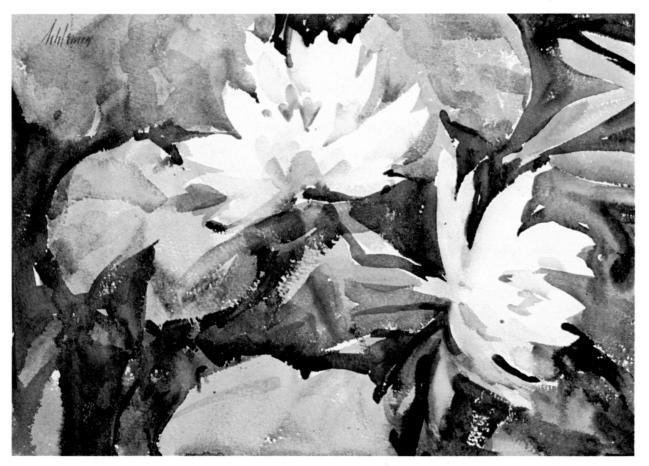

FIGURE 24. *Sharp value contrasts add to the visual excitement of the waterlilies.*

Expressive Use of Key. As a further example of the expressive use of key, look at Figures 23 and 24. The sand dunes in Figure 23 are bathed in light. Although they roll in and out of the light, the sun creeps into all the darks, making them light and airy. Using our piano analogy, we can see that the midtones and lights are all above middle C, while the dark notes are just below middle C. The lack of contrast accentuates the peacefulness of the scene.

In Figure 24, on the other hand, there are sharp value contrasts. Green is a fairly dark color to begin with. In addition, we're looking into the depths of the water. As a result, the midtones and darks are all below middle C, with just a few whites (the flowers) high in the register. They're exciting, like the brilliant high notes on a piano. The strong value contrasts gives life to the painting, just as the closeness of values in Figure 23 creates a more serene mood.

EDGES.
Key is one of the ways that light creates mood in a painting. Light also affects the edges of objects—and these edges can, in themselves, be important expressive elements. In a rapidly-painted sketch such as Figure 25, for example, you can see great variety in the way the edges are handled.

1. Hard Edge. A hard edge (Figure 25, 1) suggests strength and attracts the viewer's attention. Where the sun hits the topmost flower, I emphasize the light area by bringing it sharply against a dark background leaf.

2. Soft Edge. I don't want to attract attention to these subsidiary leaves, so I merge one with the other along a soft, hardly definable edge (Figure 25, 2).

3. Rough Brush. Using a quick, brusque movement of the brush, I break the outside edges of peripheral leaves. The rough-brush stroke (Figure 25, 3) stands between the hard and soft edge—weaker than one, stronger than the other. Although a "rough-brush" mark looks somewhat similar to what most people call a "drybrush" mark, I'm giving it a different name because I use it for a different purpose. In addition, a drybrush mark is, of course, made with a dry brush; the rough-brush stroke uses pigment *and* water. The most noticeable thing about drybrush marks is that they can cover a multitude of sins. When you make a mistake, it's easy to cover up with drybrush; you simply run the marks mechanically over the paper. I'm sure you've seen such pictures. It's a trick—like splattering paint on the paper to get "texture"—and I seldom use it. A rough-brush stroke, on the other hand, is applied vigorously, with strength but reserve, to a part of the painting—and is designed to tell us about the *character* of an object through the nature of its edge.

4. Lost and Found Edges. The leaf and the rose meet along an edge that's hard at some places and soft at others (Figure 25, 4). These hard and soft marks are typical of areas that move in and out of the light. We need this variety. If all the edges in our picture were either hard or soft, it would look too stiff—or too "pretty."

5. Broken Edge. Unlike the lost and found edge, the value contrasts along a broken edge (Figure 25, 5) are always clearly seen. Here, for example, the light rose and the dark accents cut into and across one another, breaking the edge and adding extra interest to it. I use this technique extensively in the demonstration of a flickering light. Probably one of the greatest masters of this kind of edge was the Russian-American painter Nicolai Fechin.

6. Scratches. Stems are suggested by quick marks, made in the wet wash with the end of the brush (Figure 25, 6). The lines are broken so that, once again, they have the elusive look of nature.

EXPRESSION AND EXAGGERATION.
We give expressiveness to a painting through our use of key, edges, and color. Those are the important things. Yet most painters, including myself, are always in danger of getting too involved in the details of the subject. Ed Whitney—well-known artist, teacher, and author—always said that when you bought a coat, you looked for the fit—not for the buttonholes. So don't worry about the buttonholes; instead, paint what you feel about nature.

Your feeling for a subject shows in your exaggerations. If I were painting a boat race, for example, I'd express my excitement by exaggerating the color. And the exaggeration would work, as long as it was seen *throughout* the picture. Each painting should be consistent within itself, so that if you ripped a number of them into small pieces, you could tell—just from the nature of the colors and the strokes—which pieces belong to which work.

Figures 26 and 27 should suggest what I mean. In Figure 26, I wanted to suggest the lushness and warmth of the roses. In addition to their own deep color, I warmed up the greens in the background, making them rich, too. Soft edges suggest the delicacy of the roses. In Figure 27, on the other hand, I wanted to paint the strength of the sunflowers. The edges are hard, while the background is a simple suggestion of sky. The roses seem to be tucked into a lush jungle of foliage; the sunflowers have grown high into the air—you see the sky and can imagine how tall they must be.

A WORD ABOUT WASHES.
As we've seen, nature's color is full of variety—but how can we get that feeling into our painting? Not, I think, by working as I did in art school: I can still remember classroom exercises in which I had to fill square after square with color, in an effort to get a perfectly graded wash. The more I see of nature, the more I dislike such "beautifully painted" washes. They look too much like *paint* to me; and when I

FIGURE 25.
In this quick sketch,
you can see six different
kinds of edges:
1. Hard Edge
2. Soft Edge
3. Rough Brush
4. Lost and Found Edge
5. Broken Edge
6. Scratches

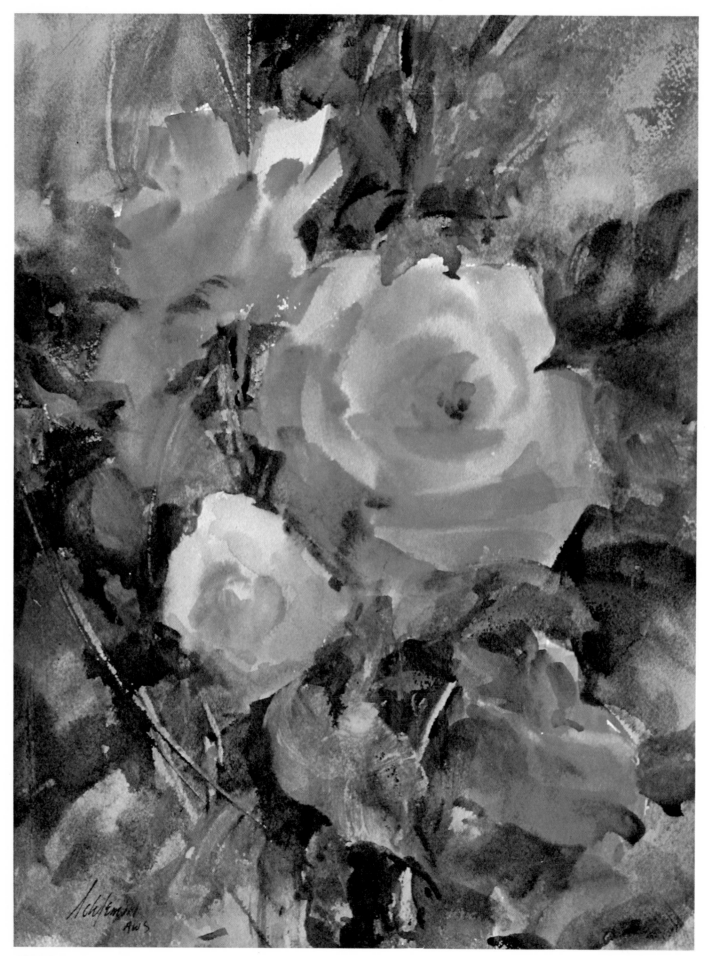

FIGURE 26. *I soften edges and enrich my color in order to suggest
the lush character of a rose. (Collection of Louise Toomey)*

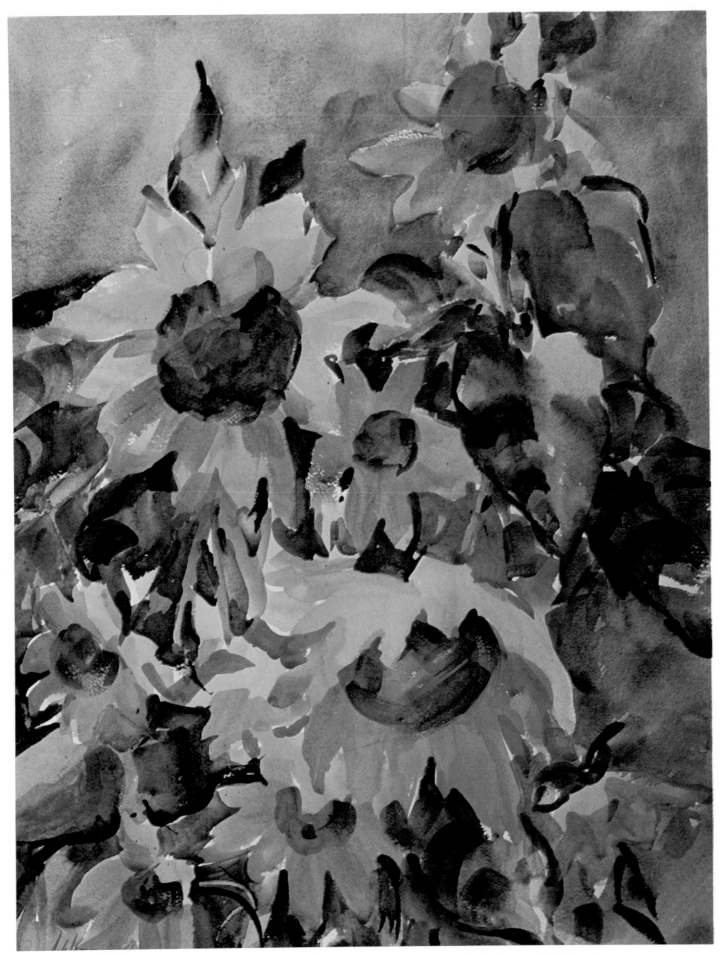

FIGURE 27. *Painting sunflowers calls for harder edges and the fresh, cool background of the sky.*

see them at a show, I feel like wetting my finger and messing them up! Anything to vary the wash and give it the rough look that I think more accurately suggests color, atmosphere, and light. Better the expressive wash, than a mechanically perfect one!

Lighter, Brighter; Darker, Duller. Mae Bennett-Brown, the fine painter of flowers, had a saying: "lighter, brighter; darker, duller." She meant that every time you touch a wash, you dull it. The white paper is the cleanest and brightest light of all. The first wash sits on the surface of the paper and is very luminous. A second wash, glazed over the first, naturally muddies and dulls the color. A third wash is duller still. And so on: lighter, brighter; darker, duller.

Light is the life of the painting. And to guarantee bright, luminous lights, the washes describing them should be lively, bright, spontaneous—and *un-worked*. Lighter, brighter. When working the first washes, I usually paint the entire object (1) in light, (2) moving from the light, and (3) turning from the light. I pull the moving and turning-from-the-light wash right into what will eventually be the out-of-light part of the object.

Instead of being brilliant and vital, the out-of-light and shadow areas should be places of rest—places to take it easy. I therefore glaze the darker washes over my first wash—now bone dry—always leaving the in-light part of the wash alone. Mess up the in-light wash and you might as well throw the paper away. In general, these second washes are (1) darker, (2) cooler, and (3) heavier in paint quality. Darker, duller. I glaze with a light touch in order to avoid lifting the first wash. It's important that you *feel* the lighter, brighter color through the darker glazes; that gives the darks luminosity and life. It also *relates* the light and out-of-light areas. All students recognize the importance of such a relationship—particularly if you've been taught to handle the light and dark sides of an object as if they were separate and distinct areas. More often than not, the object ends up looking as if it were painted two different colors. Remember: light should unify objects—not split them apart!

The Practical Approach to Washes. My belief in glazes and untouched washes is a result of my feeling about light. But there are also some very practical reasons why such a logical, step-by-step method is a good one to use. To begin with, most people find it easy to concentrate on a few ideas at a time, and the bigger the idea, the more attention you can give to it. So in the first wash, I think

"light"—and don't worry about the darks.

It's also difficult technically to do everything in one wash: you can't control your edges. Place a wet dark wash near a wet light one, for example, and the color bleeds from area to area. You touch the edge, trying to contain the washes; but the more you touch, the more you damage the paper. I want to avoid this nervous and frustrated sort of picking.

Working in a series of washes also gives you better control of your color. As you'll see in the following demonstrations, you can vary the quality and quantity of pigment, creating a variety of transparent and semi-transparent effects, a variety that parallels the kind of complex visual sensation you have when you look at nature.

There's yet another reason why I prefer to work wash over wash. It's a logical procedure. And using it, you don't get bogged down in technical questions, questions far removed from the painting process. As you work, you think about only two things: what is the subject and what is the light doing to it? You don't worry about tricks: should I sponge, scrape, or splatter? You look—and paint!

SOME EXAMPLES. I'll end this discussion by quickly looking at four paintings, each of which uses the sky for a different expressive purpose. In Figure 28, I want to emphasize the tall tower of the house. The clouds are therefore angled *toward* the building. The horizon is dark, in order to emphasize the whiteness of the house. And the clouds are kept relatively low in key, so that the tower is clearly the brightest element in the picture.

In Figure 29, I want to suggest a windy day. The boats and the rock pier can't say "wind"—so the sky has to do the job. Since I was impressed by the strength of the day, I use strong lines in the sky to exaggerate the cloud activity. These lines tell you about the day. Cover the sky with your hand and you'll see how static the picture suddenly becomes.

In Figure 30, the sky is merely a backdrop. The real activity is around the boats. I use the darks of the sky to emphasize parts of the sail, while also running the sky right into the water. The horizon was visible at the site, but I felt it was too straight and static—it would have killed the liveliness of the picture. So I left it out. Such a sky isn't "realistic" in a photographic sense. It's a foil to the active character of the rest of the painting.

There's a horizon in Figure 31, but I've broken into it with the sky. That softens the line and makes you feel as if you could travel over it and far out to sea. It's an important edge, for it helps express the expansive feeling I get when at the seashore.

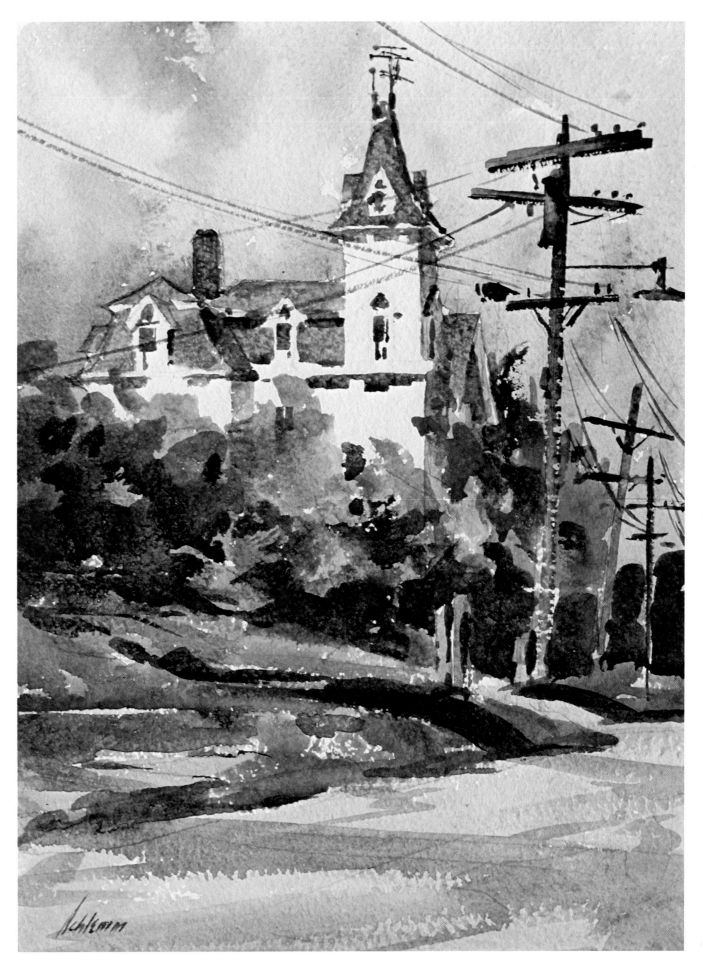

FIGURE 28. *I angle the dark sky toward the house in order
to emphasize its white tower. (Collection of Louise Toomey)*

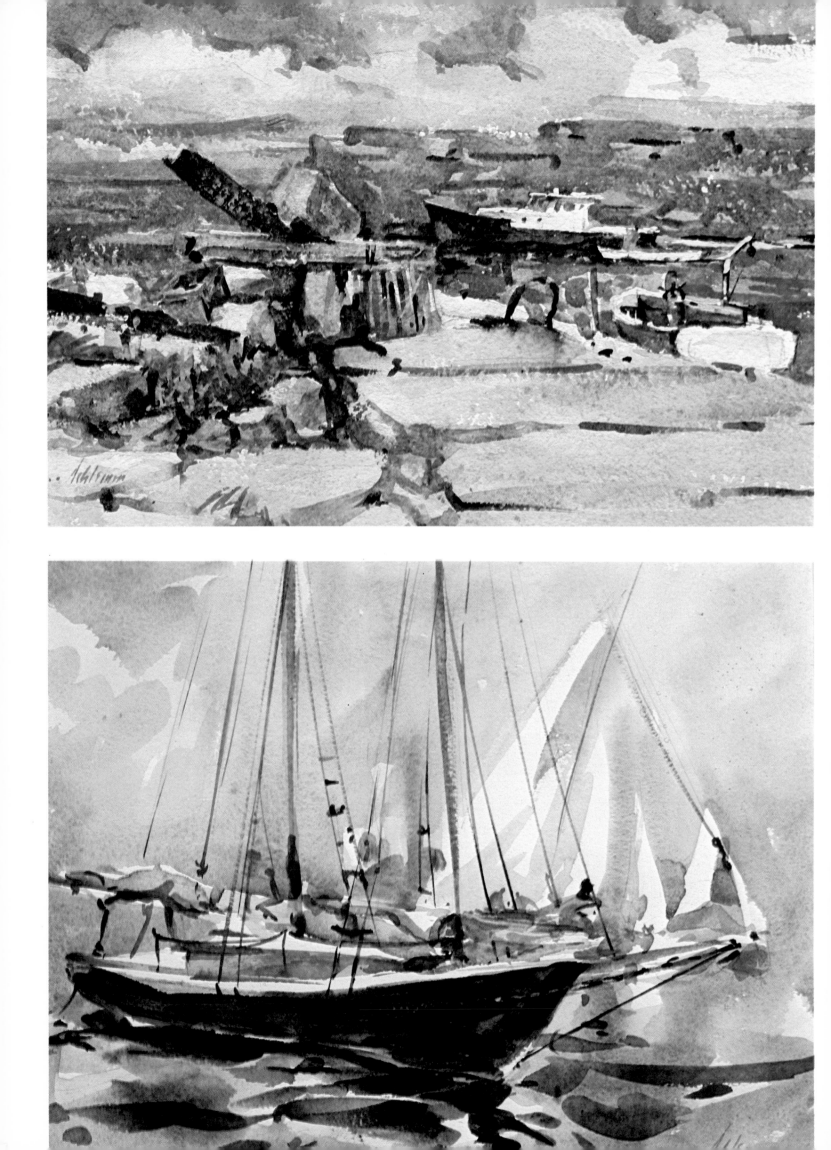

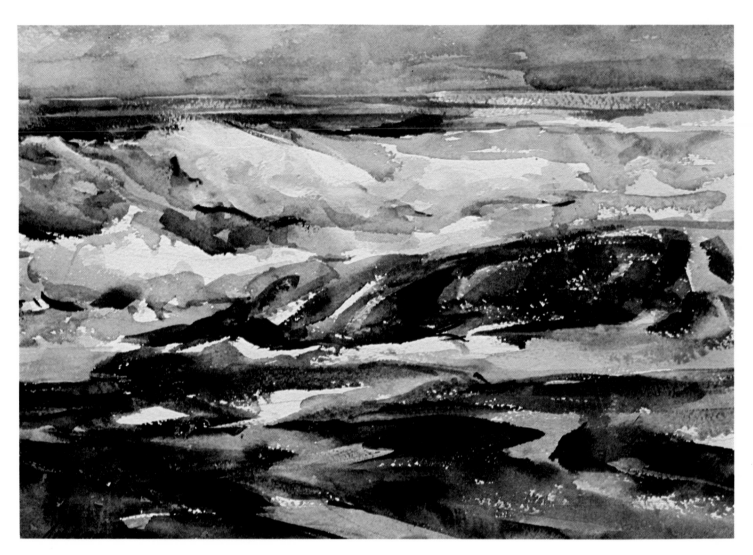

FIGURE 29. *(Top left) The use of line in the clouds gives the sky strength and suggests the windiness of the day. (Collection of Louise Toomey)*

FIGURE 30. *(Left) The sky is a backdrop for the boats, emphasizing the sails and obliterating the horizon. (Collection of Louise Toomey)*

FIGURE 31. *(Above) The sky breaks into the horizon, softening it and giving you the feeling that you could sail over it and out to sea.*

Procedure

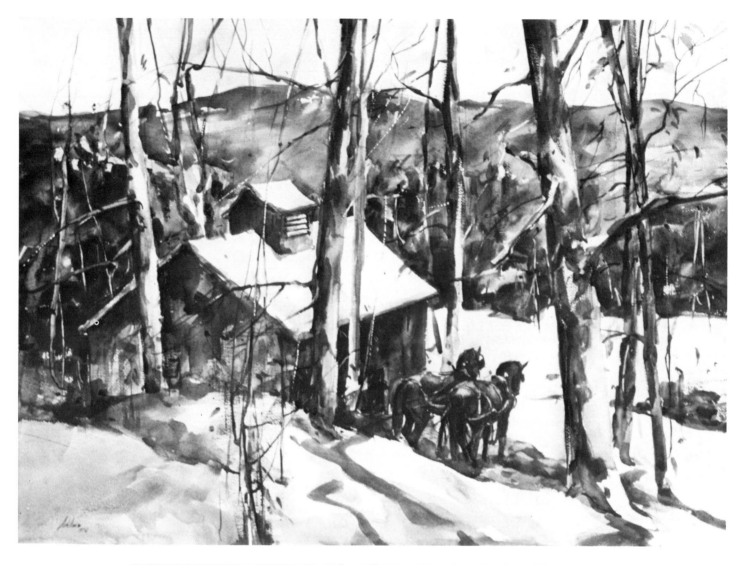

JEFFERSONVILLE WINTER, 22" x 30" (56 x 76 cm), collection of Louise
Toomey. This is a primarily linear design, a pattern set by the long lines of the
upright trees. The foreground shadows repeat the linear theme. They also lead
you into the picture and, by moving over the snow, give you a sense of the lay of
the land. All with a minimum of effort on the part of the painter!

In order to make my later, more-detailed demonstrations understandable, I'm going to discuss the practical application of the ideas expressed in Chapters 3 and 4 in the following demonstration.

DECISIONS BEFORE YOU PAINT.

Certain decisions have to be made even before you start to paint. For example: What kind of day is it? Where is the sun? "Over there," many students say, running their hand across the left-hand side of their paper. They don't realize that you have to pinpoint the sun in the sky. Is it to the left or right? Is it high or low? In front of you or behind you? Each shift in position changes the character of the subject. That's why watercolorists learn to work quickly outdoors.

The light determines the quality of the edges, the vibrancy of the color, and the contrast between values (the key of the picture). You have to determine your theme, the kind of mass and line that corresponds to the theme—and even the paper that best fits the particular subject. I'll discuss these questions in each of the following demonstrations, for I never start to paint till each has been answered in my mind. There's danger in watercolor when you only half-know—and then try to correct while you paint. *Know* first—and the medium will work for you.

In this case, I'm painting horses on a gray, very cold day. Snow is in the air, softening all the edges. I work hard to draw the horses correctly—but my real subject is the quiet mood of the day. I paint what I feel, not just what I see.

STEP 1. I first paint the warm sky, preparing the area by wetting it in a hit-or-miss fashion; the wet paper gives me a better control of the wash. The sky color reflects down on the upright planes of the snow. This makes more sense, I think, than the old watercolor practice of unifying a picture by throwing a lot of earth color into the heavens. Pretend, instead, that you're the sun and sky—and gently touch the planes of the earth with suggestions of sun and sky color.

Notice the difference in the snow areas to the left of the foreground horse. At its hooves, the horizontal plane of snow is touched with light, warm color. The sky directly affects it. The light has less of an effect on the slanted snowbank to the left of the horse's head, however; it turns from the light and is therefore darker and cooler.

As you can see, the background wash contains a variety of textures and colors. You don't find many flat tones in nature—so I try to get away from the feeling of paint by letting the pigments do beautiful things by themselves. Water is the key. Remember: it's waterCOLOR when we discuss light; but WATERcolor when we apply our washes. Too much pigment makes a wash opaque and dead. Water breaks up the washes and emphasizes the paper—our most precious commodity.

Pack as much information into your first wash as you can—subject to the technical limitations that we've already discussed. I paint the areas inch by inch, color change by color change—discovering the subject as I make a more careful study of it. The more I look, the more I see. I try to keep things soft in these first washes, adding dark accents and hard edges toward the end of the painting process.

STEP 2. I glaze over the background with dark washes that represent trees and branches. I let the sky show here and there. Elsewhere, it's felt through the darker washes—so you always feel the sky is affecting the mass. I couldn't get this effect by painting the background in one process; I need both the first wash and the later glazes.

I have great variety within the background mass: rough brushstrokes, wet-in-wet areas, hard edges, soft edges—even a few scratched lines. I keep my statements simple, not worrying about individual trees. If I start to worry about them, I'll forget why I'm painting the picture in the first place. I also let my washes work for me. Notice, for example, how one wash does many things: pulled over an out-of-light area, for example, it both softens edges and dulls color—thus making the in-light areas seem all the more sharp and clean.

Notice also that I don't finish the picture piece by piece. I work all over the paper, as would an oil painter. Remember: we're painters first—painters who just happen to use watercolor!

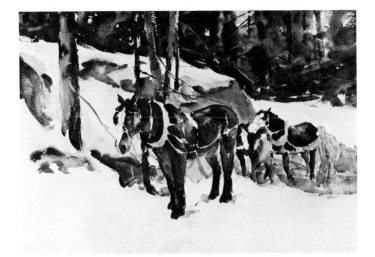

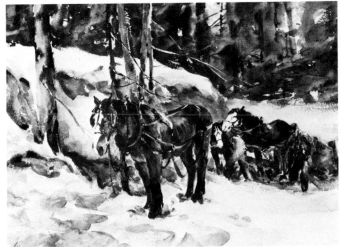

STEP 3. As in the previous steps, I use the first wash to model the foreground horse. While the wash is wet, I can't put in a lot of dark accents—so I leave them for the later steps. I study the horse, putting in the color changes where I see them. Notice, for example, how the warm light of the sky touches the back of the horse—exactly as it reflects down onto the snow. There's more blue (cooler color) on the side of the horse as it turns from the light.

I lighten parts of the horse by adding water—*and* color. Students tend to lighten areas by adding water alone. But nothing damages a design more than having the lights all go to white. You end up with a bunch of disjointed spots. Lithographers know all about the problem; working in black and white, they soon become masters of the midtone. They carefully keep most of their highlights low in value so that the important ones stand out.

STEP 4. I glaze over the snow, defining the different planes and introducing a lot of rhythmic lines in the foreground. They suggest the effect of the wind on the snow. Touches of cool color in the out-of-light areas add excitement to the foreground.

Now that the wash is dry, I return to the foreground horse, adding dark, no-light accents and further defining planes by additional glazes. The varied washes give the horse character and suggest different surface qualities. Yet because the preliminary wash is felt beneath the glazes, the horse holds together as a unit. It doesn't become a series of disjointed spots.

I always stop work on a watercolor just before it's finished. I rest, evaluate, and think about corrections—before everything dries and corrections become almost impossible to make. The important question is: Can the corrections be made without ruining the watercolor? You should *feel* the paper coming through our washes. But if you overwork the washes, you lose the feeling both of the paper and of the light. So, if you don't know what to do, stop! But if you've figured out a problem, push ahead and see what happens. Never simply throw the paper away. You'll just hit the same problem again someday—and, again, you won't know what to do. Each painting—even a failure—is a learning experience; it prepares you for the next attempt.

Demonstrations

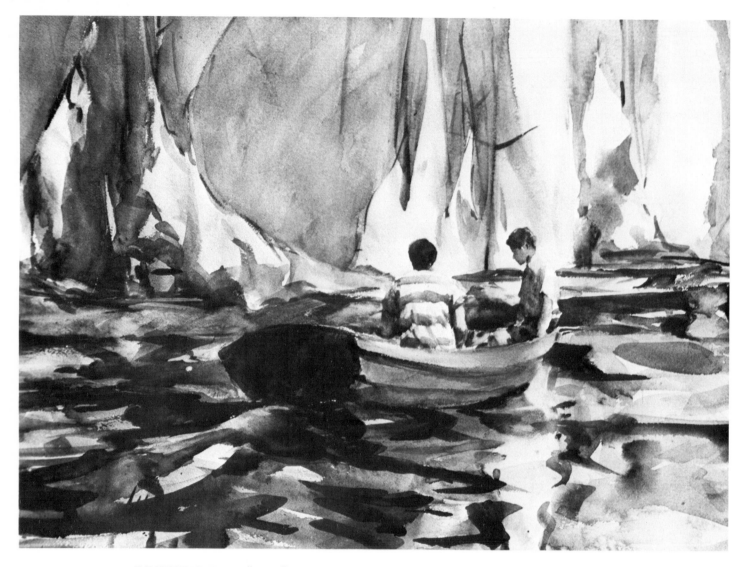

DRIFTING IN, *18" x 24" (46 x 61 cm). Children constantly play around the local yacht club, and in this picture I decided to make them my center of interest. The masses of sails are used as a simple backdrop. I painted the boats, water, and sails on the spot. But I don't consider myself a figure painter and so saved painting the children for the studio, where I could give them more attention. On location, I quickly spotted in the boys—and took a number of reference photos. But back home, I was careful not to copy these photographic poses. They inevitably look too stiff and awkward. Such photos give the painter an added security—but they have to be used in conjunction with your own knowledge of how the human body works.*

We've discussed materials, color, and the way my ideas about light affect my washes. The demonstrations that follow look more specifically at all these questions.

I should stress that in the following demonstrations, I have no intention of listing every pigment I use to mix a particular color. I could make such a list. But the list would be useless. The exact colors I use and their proportions in each mix always change from day to day, depending on the quality of the light and, just as importantly, on how I happen to feel at the time. If, for example, there were one and only one way to mix the color of a brass samovar, or a summer day, or the Atlantic Ocean, painting would merely be the application of mechanical formulas. You might as well let a computer paint your picture. In the following demonstrations, then, I'm not interested in giving you color recipes. Instead, I'll try to suggest ways of working which will make you (1) *look* more closely at nature and (2) *think* more before you paint.

You'll notice that in each demonstration the light changes, but my painting procedure remains the same. That's the rule of the game. Some people dislike rules; but I find that a particular way of working gives me an extra freedom. Rather than worry about technique, I can concentrate on the more important problem of interpretation.

This procedure works for me—but may not work for you. And you'll certainly want to change and modify my ideas in order to make them fit your own needs and purposes. I'll be happy if the following demonstrations start you thinking about light and form. I'll be unhappy if they only show you how to paint the subjects I like—for that's of little help when you decide to paint the subjects *you* like!

1. Light on Curved Surfaces

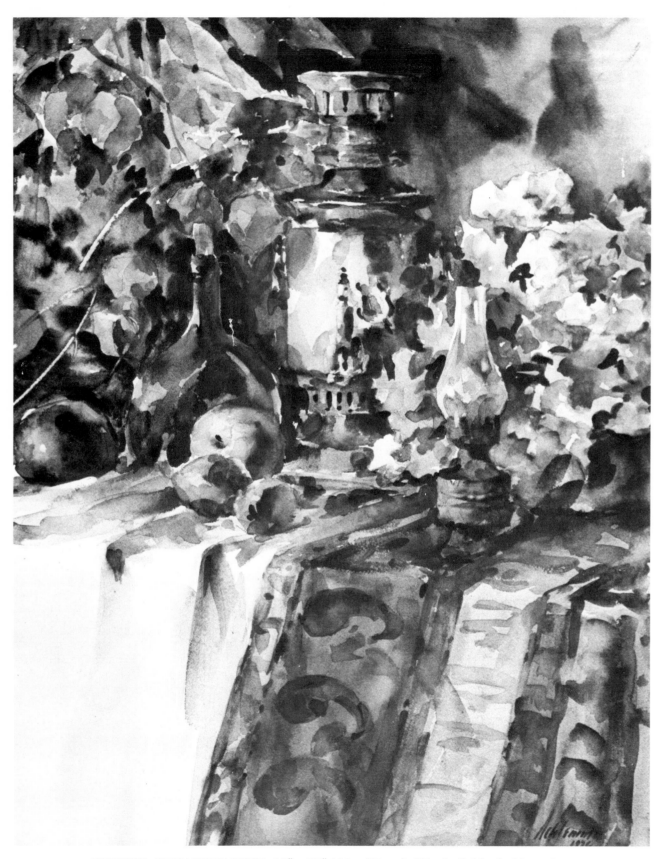

JENNY'S ARRANGEMENT, *18" x 15" (46 x 38 cm). The individual objects in this still-life interest me less than the way the light plays over them. I emphasize the varied highlights by losing the out-of-light edges of the objects. The light is very close—it's almost a one-source light—and little light can sneak in from other directions. The shadows become dark and almost colorless.*

In the following demonstration, the folds of the fabric and the samovar are both interesting, but the apples are the real focal point. I've aimed the spotlight directly at them; and it is this light, of course, that tells you where to look *first*. It defines the subject. This is really a teaching demonstration; I'm less excited by the subject itself than by what it shows you about the effect of light on rounded surfaces.

LIGHT. I usually light my still-lifes with a hundred-watt bulb in a standard photographer's lamp. In the following demonstration, the eye naturally follows the path of light through the picture, moving from the left side—closest to the light—to the right. The pattern of light moves from a light to a dark area, as well as from a warm area (nearest the light) to a cool one (the shadows on the right-hand side). Because of the nearness of the light, we get fairly rapid changes in color and value. The red drape lit by the yellow bulb also makes the picture extremely warm. Notice that sharp edges occur in the foreground, where the light and dark contrasts are most pronounced. However, the edges soften rapidly as the objects recede from the light.

KEY. This still-life is in a middle key, with most of the midtone values clustering around what, in our piano analogy, we called middle C. This is not an especially exciting value range, but I'm more interested in the warm color of the subject than in the value contrasts. Painting all that red and orange is the real challenge. In future demonstrations, midtone values will play a more important and expressive part in the designing process.

PAPER. The painting is done on a block of Arches 140-lb rough watercolor paper. I don't usually recommend buying the expensive blocks; but in this case, the 18″ x 24″ (46 x 35.5 cm) size just happened to suit the subject. A regular half sheet would be too long, and a full sheet too big. The paper also sponges clean easily, making it possible for me to correct the washes.

PLANNING THE COMPOSITION. There's one great advantage to a still-life: unlike nature, it can be conveniently arranged and rearranged in the studio. Since I'm interested in light and in the way it falls on objects—rather than in the objects themselves—I always use a spotlight while arranging the still-life. I can later experiment by moving the light closer and farther away. I place the objects carefully and shape the folds of the cloth so they form map-like "directionals" leading the viewer into the design. I curve and break these lines so that

they're interesting to look at; I don't want to zip the viewer abruptly in and out of the composition.

Changes in lighting can radically alter the feeling of a still-life. In Figure 32, for example, the still-life is under the general, allover illumination of the studio. It's not a light I find very interesting. In Figure 33, the light is on the right, close to the subject. The effect is dramatic, but there's no pattern to the light areas—just a bunch of disorganized spots. The lights should group together, making it easier for the viewer to understand your composition. In Figure 34, I've unified the design by moving the light to the left. This kind of one-source light is also dramatic—but in painting the darks, you're apt to make your colors too opaque and thus lose their vibrancy.

Figure 35 shows the still-life under the light I like best. There's the same close light as in Figure 34, but I've added another light farther off in the room. This extra light throws interesting color into what are basically out-of-light areas (see the chapter on light). The color is broken up, and the subtle warm and cool shifts within the out-of-light darks are a challenge to paint.

PRELIMINARY SKETCHES. When drawing the arrangement, I first tried a number of rough sketches using a horizontal format. But I always ended up with too much cloth on one side or the other. The subject is clearly a vertical one. If it were *all* vertical, however, it wouldn't be very interesting to look at. I vary the design by introducing some horizontal and diagonal lines—note, for example, the folds of the cloth. These contrasting lines knit the subject together.

The samovar was relatively easy to draw—I just divided it into three units and compared the proportions. I omitted the wooden handles because they looked too much like little ears.

The hardest part of the drawing is always the placement of objects on the paper so that they're varied in shape and exciting to look at. The pieces of white drapery gave me the most trouble. A watercolor is always enhanced by the use of white paper—white areas are our most precious commodity. However, if these shapes are too small or unplanned, they might as well be left out altogether.

Once the drawing is complete, I erase the pencil lines in the in-light areas. The lead pencil line in this wash is distracting and destroys the feeling of light. In the out-of-light areas, such pencil lines aren't as much of a problem. You can't see them. In fact, I take my pencil and darken some lines in these areas to remind myself where I plan to place important accents.

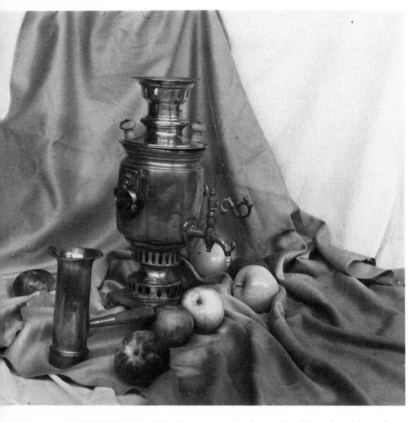

FIGURE 32. *Under a general studio illumination, the still-life has few contrasts and no real center of interest.*

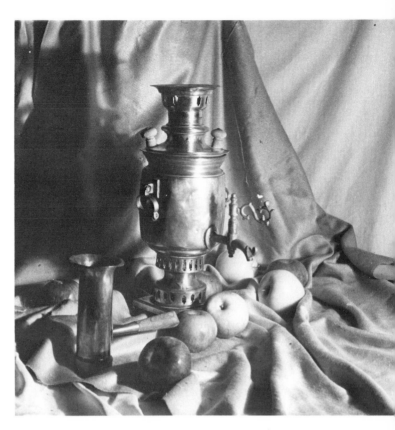

FIGURE 33. *The light is close to the still-life and to the right, dramatizing the subject but creating no real pattern of lights.*

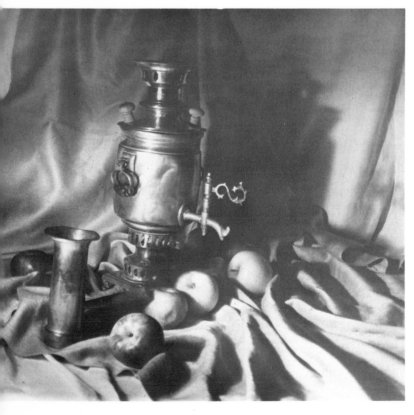

FIGURE 34. *The light is again close—but to the left. Although the lights are organized, the dark areas are a problem, tempting us to use too much opaque color.*

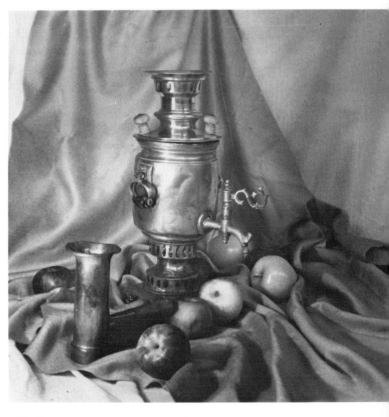

FIGURE 35. *The light remains to the left, but a second, distant, light is added, throwing color into the out-of-light areas.*

STEP 1. *The complete drawing should lay in all the basic forms of the composition. Remember that a painter thinks in terms of color and value rather than line. You won't know what's really important in a picture till you've covered most of the paper with color. However,* *never slight your preliminary drawing. Always give it that extra bit of consideration. Be sure of yourself, never "approximate"—and the painting process will be all that much easier.*

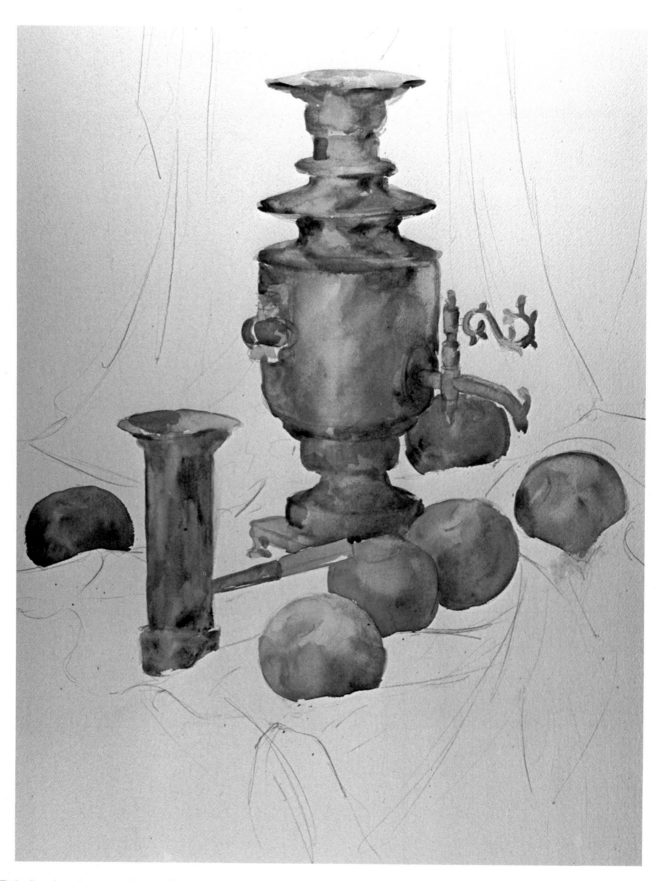

STEP 2. *I paint the areas in the light and turning-from-the-light (the halftone areas) first. There are no real darks at this stage. I start with the samovar, for if I spatter paint while doing it, I can easily sponge the surrounding paper clean (a hard task, had the background been painted first). I use lots of water in the washes—a wet wash is always rich. Also, I frequently change my water, especially when using yellow. Yellow is an opaque color, and the accumulated sediment in the water can dirty all your other washes. Be sure to cover the areas that you're painting thoroughly—too many specks of white paper can be a distraction, for they break up form and destroy the pattern of light.*

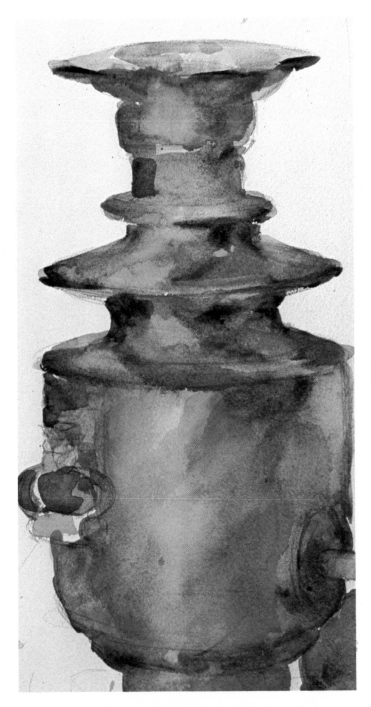

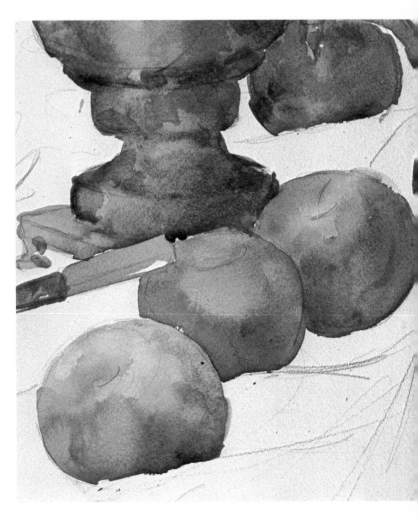

DETAIL. *There's no recipe for painting brass. It has its own local color, and reflects all the colors of its surroundings. I paint the highlight first. It's near the lamp and therefore has a lot of warm lemon yellow in it. As the form moves from the light, I add cerulean blue to cool the lemon yellow. Cerulean blue is a warm blue; by using it I make the shape recede in space while also keeping it from going too cool, and therefore out of the light. As the samovar moves farther from the light, I substitute the duller yellow ochre for lemon yellow. Still farther from the light, raw sienna replaces yellow ochre. I also add other color spots where I see them: the warm red on the lip of the samovar and the cool reflected light on its base.*

DETAIL. *In-light areas demand clean washes, so I change the water before beginning the apples. The apple nearest to the lamp gets the strongest blast of light. I again use lemon yellow close to the light. As the apple moves from the light, cadmium scarlet dulls the lemon yellow. In what will eventually be the out-of-light area of the apple, cadmium scarlet and alizarin crimson give a feeling of weight and solidity. On the right edge, the apple catches a cool reflected light (cerulean blue). Since this is a light, not a shadow, it has to be transparent. The second apple, which is farther from the light, is painted with a duller yellow ochre highlight; a cool alizarin crimson moves the apple from the light.*

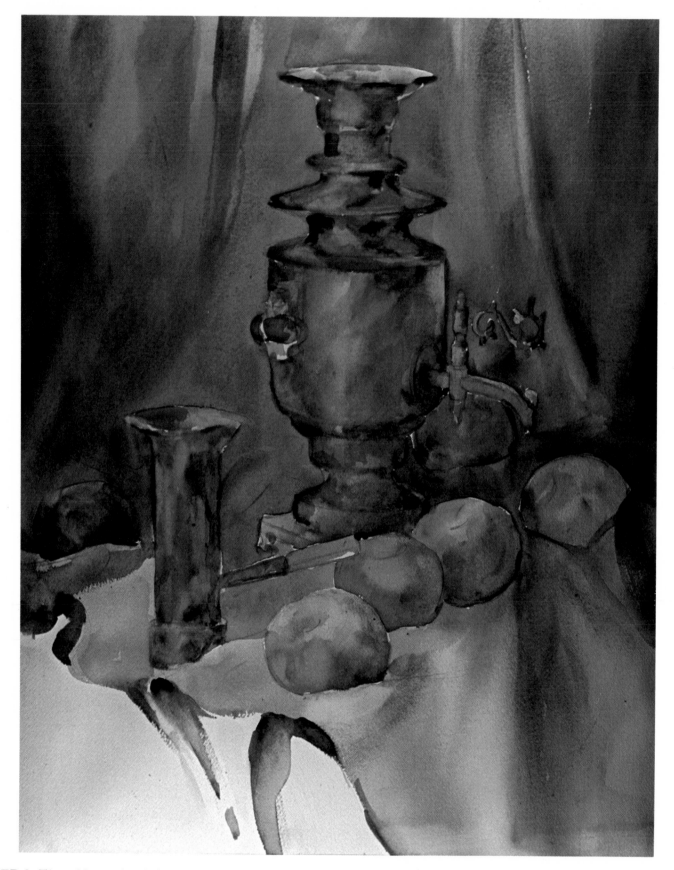

STEP 3. The white and red draperies are handled with big washes and have to be done cleanly and without stopping! I wet the paper in a hit-or-miss fashion, then use lemon yellow with alizarin crimson for the in-light area. As the drapery moves from the light, yellow ochre and cerulean replace the lemon yellow. For out-of-light areas, I let cobalt blue replace the warmer cerulean blue. Various mixtures of ultramarine blue, cadmium scarlet, and alizarin crimson are used in the darkest areas, with yellow ochre dropped into the wash to suggest the reflections of warm light. The piece of white cloth on the right, which is out of the light, is painted with cobalt blue and light red. Again, I add warm color (cerulean blue and raw sienna) to echo the warm colors in the rest of the picture.

DETAIL. *This foreground cloth is particularly challenging to paint, for it must be handled with the utmost simplicity. Remember: the foreground should always be sure, direct, and clean. It should be painted with authority, so the viewer can easily step over it into the picture. If possible, paint it in one touch! In this case, the out-of-light darks (the shadows painted with cobalt blue and raw sienna, and grayed with cadmium scarlet) are almost oriental in character. They're crisp, but not so "pretty" that they attract attention. There's a great variation in color and in weight of paint within these darks; you feel you can look into them.*

DETAIL. *I begin to model the apple around the stem. The untouched first wash suggests a highlight. Lemon yellow and cadmium scarlet dull the in-light area: cadmium scarlet moves the apple from the light into an out-of-light area; and alizarin crimson (a cool red) and cobalt blue take the apple out of the light. Notice how the apples, as they recede, lose in value, brightness, and sharpness of edge. Though only inches from the first apple, the background ones are perceptibly different in color.*

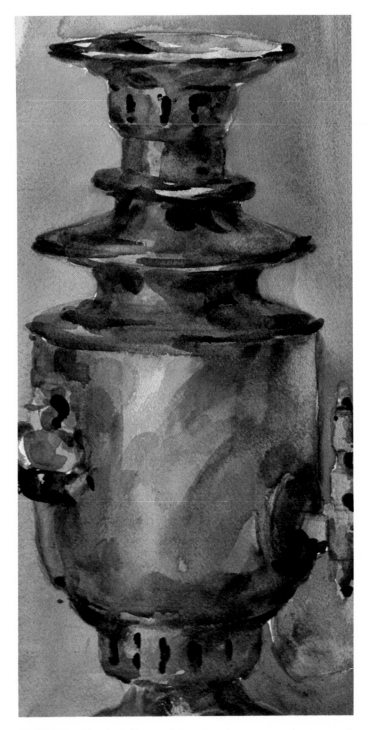

DETAIL. *The heavier and less luminous raw sienna and cobalt blue are glazed over the turning-from-the-light and out-of-light areas on both sides of the samovar. Notice, however, that the highlight is carefully left untouched. Can you feel the "heaviness" of the washes to the right and left of the highlight? They've been touched a second time—and are duller in character. Yet they're not opaque—you can feel the paper beneath them. These areas contrast with the lighter, simpler in-light washes and make them look all the more fresh and transparent. The dullness of one wash emphasizes the brilliance of another.*

JENNY'S SAMOVAR, 18" x 24" (46 x 61 cm).

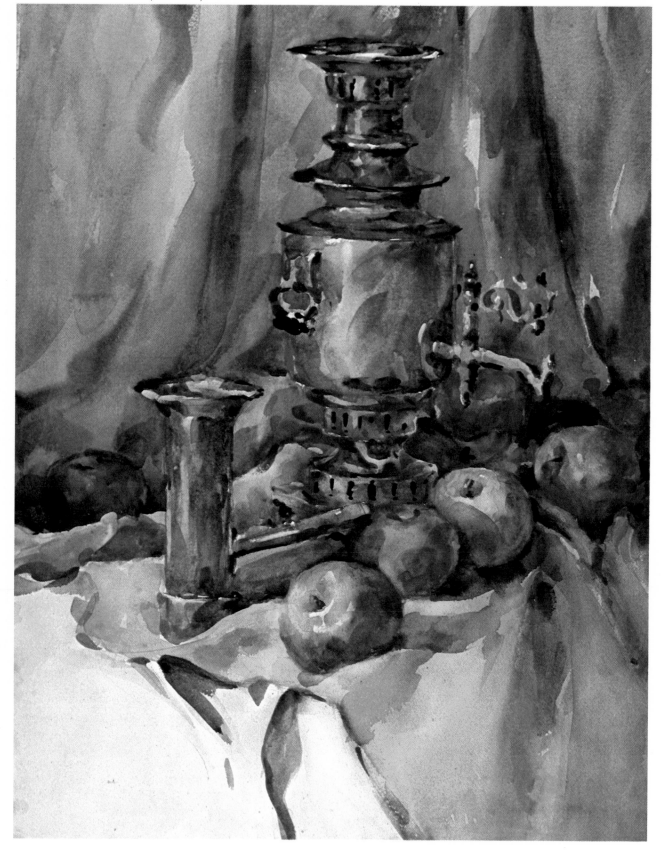

STEP 4. *I add glazes to deepen the background drapery (it was too wishy-washy) using the same colors as before, but charging the wash with cadmium yellow. The yellow gives the area a warm, luminous look. As long as a bit of the first clean wash is visible (in the upper right, for example), the reworked wash still seems to have light in it. I also sponge out the folds on the upper left, repaint-*ing *them to avoid too many straight lines. Notice the difference in color between the in-light foreground apple and the apples on the far left and right. The apple on the left is painted with a cool wash of alizarin crimson, cobalt blue, and a touch of cadmium scarlet. The one on the right is a mixture of raw sienna and Winsor green. The washes are dull; the apples are clearly far from the light.*

DETAIL. *The part of the fold angled toward the light is warm; that angled from the light, cool. Yet the movement is only one of a few inches. Notice that the cloth washes are neither simple nor flat. Warm light plays in the cool areas, and some cool color is felt in the warmer pieces of cloth. The edge between the red and white drapery is very important. It's a "lost and found" edge, broken by darks and reflected lights. I didn't want a hard edge between these two materials, for you'd see it before you saw the apples and samovar. Remember: many a painting is lost because of a false edge!*

DETAIL. *The reworked parts of the drapery look dull, so I tried to brighten the color by adding luminous, opaque touches of both cerulean and cobalt blues. I exaggerated; but the exaggeration works, for the nearness of the light bulb has equally exaggerated the in-light areas. The cast shadow on the background apple is made with cobalt blue and a lot of water. The water assures that the cast shadow is soft and filled with light. I also use cobalt blue in the lower part of the foreground apple—but this time I gray the color with yellow ochre and cadmium scarlet.*

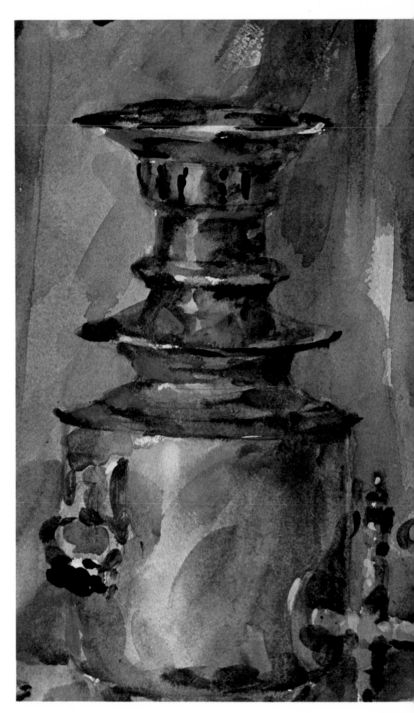

DETAIL. *Dark accents enliven the picture. Notice the edges and the handles of the samovar. Some of these accents also suggest where the surface of the samovar reflects parts of dark, nearby objects. The tracery holes at the top of the samovar are true no-light areas; they're so small that light can't get into them.*

2. Light on Angular Surfaces

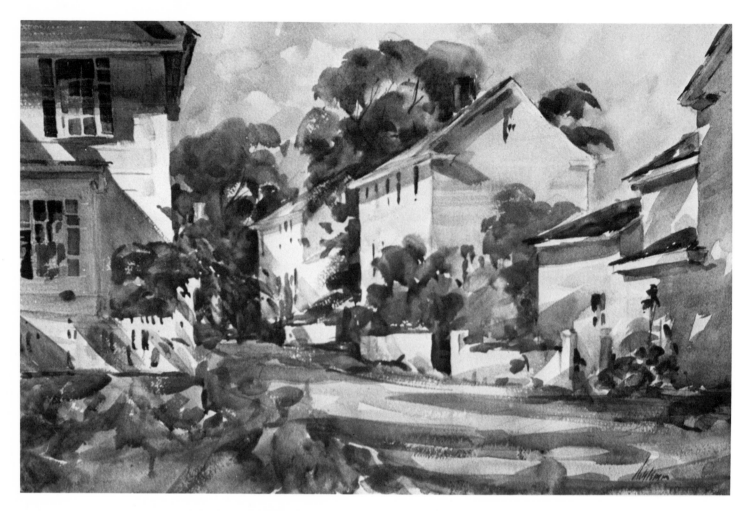

GOTT STREET, ROCKPORT, *14" x 21" (36 x 53 cm), collection of Mrs.*
Florence Chadbourne. Here cast shadows are an important part of the design.
The angular shadow across the house on the left points you down the street.
Similarly, a large shadow kills the form of the house on the far right. At the site,
this house was in full light—but a bright spot that close to the frame would
attract the eye and keep it from moving into the picture.

Now that we've studied curved shapes indoors, let's go outdoors and see how sunlight affects angular, architectural forms.

LIGHT. In the still-life, the spotlight was close and very strong. This time, let's study a hazy spring day. On such a day, the light is diffused by the clouds and moisture in the air. Many of the edges, because of the veils of atmosphere, are soft rather than hard. To assure fairly soft edges, I use a lot of water in the washes. This "soft" light seems to me especially characteristic of the delicacy of the season—it expresses something I feel about this easy, lazy time of year.

KEY. This is a happy day—painted in a major key. The lights and midtones are close together, above middle C. There are only a few real darks. I don't want a lot of big value jumps; they'd make the picture too busy, too exciting. I don't feel that kind of excitement on a spring day. It's like playing the piano with a tender touch—not thumping the keys wildly! The springtime calls for understatement, just as summer usually calls for some expressive exaggeration.

PAPER. The painting is done on Arches 260-lb cold-press paper. It's a medium paper, neither hard nor soft, and takes both good washes and a good beating. Color sponges off easily, so I can make corrections over cleaned areas and still get freshness in my washes. I use an elephant-size sheet, cut in half (20″ x 25″/50.8 x 63.5 cm). That gives me a fairly square piece of paper—a good size, since it allows me to emphasize the houses without having a lot of paper to fill up on either side of them. The only trouble with this paper is that its finish is a somewhat dull white, though not noticeably so.

PLANNING THE COMPOSITION.
Figure 36 is a photo of the site of the following painting—exactly as it looks. I took the photo in winter, so you can clearly see all the trees and bushes. Figure 37 is one of the first quick sketches I did on the spot. I simply stood in the street and drew everything. Later, once I understand a subject, I can decide what to leave out.

Seen from this angle, the street looks very complicated—especially since I'm looking at both the fronts and sides of the houses, thus creating a complicated problem in perspective. By stepping over the wall to my left—a move of about ten feet (three meters)—I lose the side of the distant building. The perspective is simpler, and, again, this simplicity seems to fit the quiet character of the season. By moving this amount, I also bring the two main houses closer together; they form a unit, two white shapes that fit together like pieces in a jigsaw puzzle.

In the preliminary drawing, I emphasize also the verticality of the New England houses; that uprightness symbolizes for me the propriety and dignity of the people. I echo the vertical movement in the lines of the tall nearby trees. I use these dark trees much as I used the folds of cloth in our first demonstration, to lead your eye into the picture, while the in-light parts of the houses (near the eaves) pull your eye up into the center.

The trees are arranged so they slant slightly from the vertical—and aren't parallel to one another. I use the curved lines of the foreground cherry trees to break into what otherwise might be an excessively angular design.

The challenge of the picture is to get the viewer to step over the foreground stone wall and into the picture. Sometimes such a wall can be an insurmountable obstacle—especially when the wall parallels the frame. Here, however, I've broken into the wall. I've pulled trees in front of it, and the line of these trees helps you get into the background.

FIGURE 36. *In reality, the site is a tangle of trees and bushes, further confused by the difficult perspective of the buildings.*

FIGURE 37. *In my first exploratory sketches, I paint most of what I see. Later, when I understand the site, I can decide what to leave out.*

STEP 1. *The perspective in the drawing is kept simple, and much of the underbrush at the site is eliminated. Verticals are accented in order to emphasize the height of the houses. Notice that I've drawn the architecture carefully; I don't want to have to "correct" the drawing once I've begun to paint.*

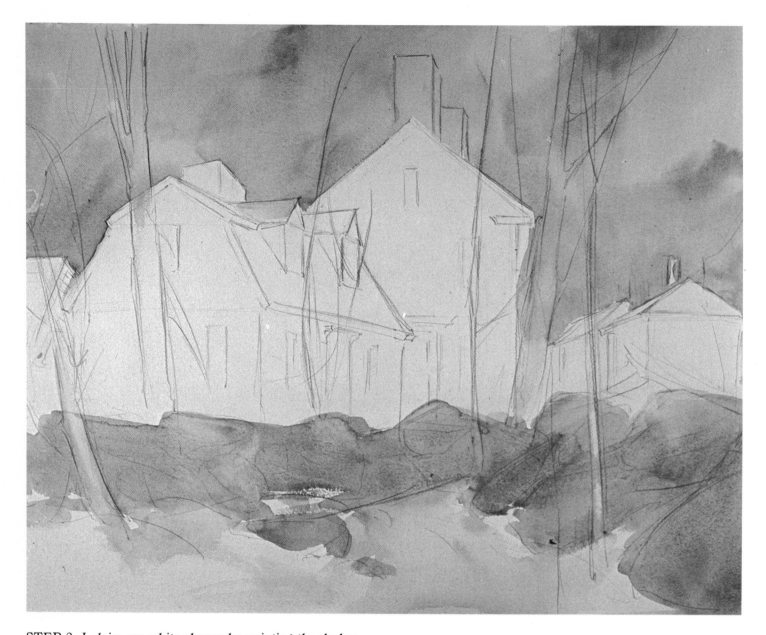

STEP 2. *I claim my white shapes by painting the darker sky and wall. I establish the more subtle relationships first, before I put any real darks on the paper—such darks might confuse my eye. The clouds are a warm, pearly gray (cerulean blue, yellow ochre, and cadmium scarlet). Starting carefully, I establish the edge where sky and houses meet, then freely work from that edge into the sky. I'd be a nervous wreck if I started the other way 'round. The sky darkens as it nears the houses, thus emphasizing their whiteness. Blue sky is painted into the wet wash (cerulean blue near the horizon and cobalt blue near the zenith), shaping the clouds into directionals that point your eye into the picture. The same sky color, slightly darker, touches the colorless rocks. There's more yellow ochre in the wall nearer the sun (left), and more blue in the wash as the wall moves from the light. Rock color is pulled into the foreground, so the wall won't look pasted over the grass.*

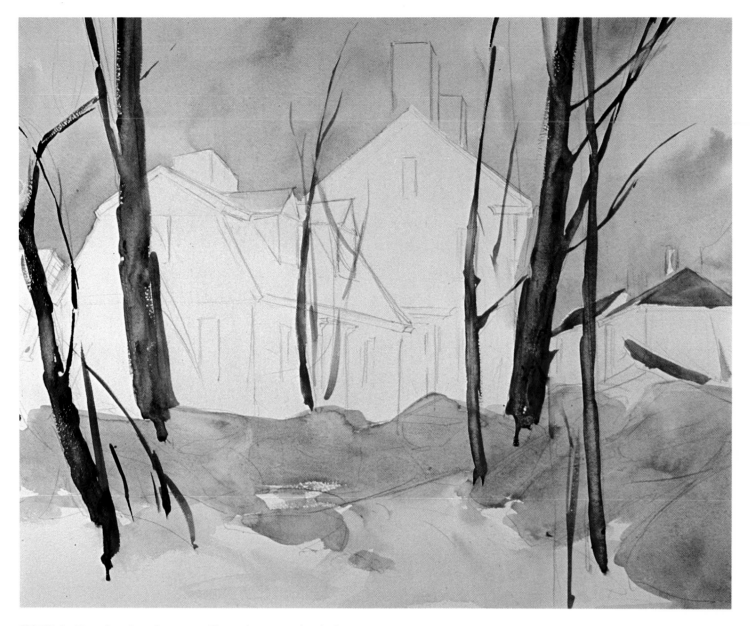

STEP 3. *Now I paint the trees. Raw sienna and cobalt blue give the trees weight. I pay close attention to the way the trees end when they meet the wall—that's a dark shape against a light one, and people will notice it. The trees are dark, but not too dark. They catch a lot of direct and reflected light. Water, thrown into the middle of the tree trunks, pushes color aside and rounds the trees. Here and there, rough-brush marks add variety to the edges without softening the trees' strength. There are subtle color differences in each tree: alizarin crimson is added to one, burnt sienna to another. On the far left, a partially mixed wash of burnt sienna and ultramarine blue suggests the dark, irregular texture of the bark of a cherry tree.*

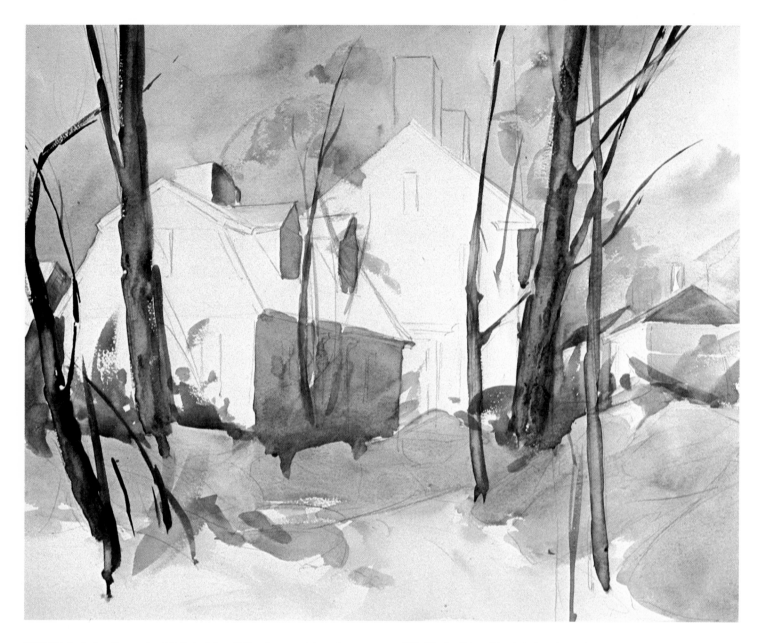

STEP 4. *I do the out-of-light side of the house, changing my water so I'm sure to get a clean wash. Since everything has its own color and value, the out-of-light side of the house (yellow ochre, cobalt blue, and alizarin crimson) is different from the sky. I use horizontal strokes, paralleling the direction of the clapboards. Under the eaves, the cottage catches a warm reflected light from the ground (cadmium scarlet and yellow ochre) while the dormers get a lot of cool reflected light from the sky. I paint the buds on the trees (alizarin crimson and yellow ochre) as tonal masses. These masses work up into the picture, breaking and softening the edges of the trees and buildings. Notice how one mass is pulled directly across a dormer—thus emphasizing one dormer, not two. Notice particularly how dark the out-of-light side of the house is—a fact students often forget.*

STEP 5. *(Top Right) I paint the grass and wall at the same time, so they're related to one another—like your fingers when you clasp your hands. I use alizarin crimson and ultramarine blue for my foreground darks (the dead leaves and crevices in the rocks). The color appears on both sides of the wall, thus relating the two areas. Notice that the main light and dark contrasts are at the center of the picture. The eye is attracted by this contrast. The dead winter grass (cobalt blue, raw sienna, and a touch of cadmium scarlet) has only a whisper of green in it. Sky color (yellow ochre and cerulean blue) reflects down onto the top of the grass, further quieting the color. The stroke follows the pitch and toss of the earth. I soften the edges where the wall fits into the ground.*

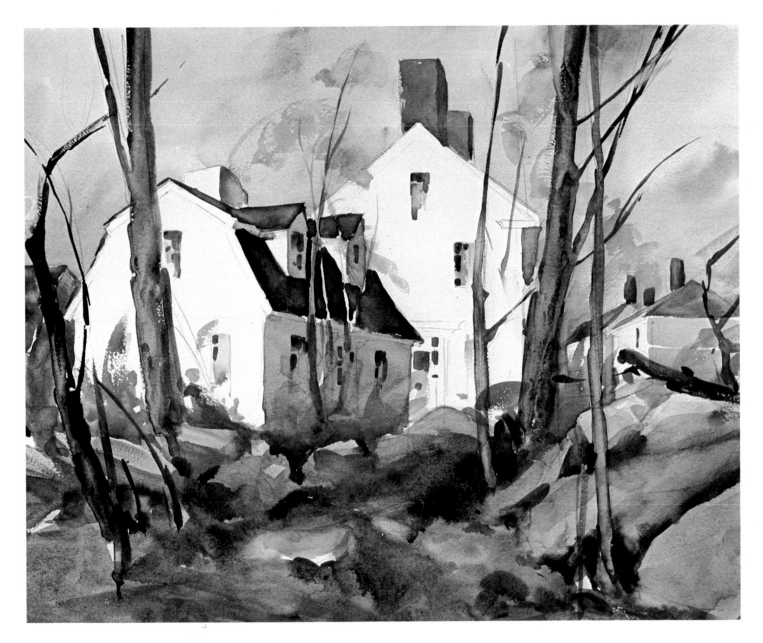

DETAIL. *I now paint the windows and doors (raw sienna and cobalt blue), making each different from the others and introducing warm color here and there to suggest reflected light from the sky. Winsor green and burnt sienna are used for the moss green of the roof. The roof is painted around the saplings; if I occasionally break into them, that's okay! Better that, than the mechanical perfection of maskoid or a razor. Once the dark wash is down, I throw sky color (cerulean blue) onto the top of the gambrel roof where it turns from the light. Where a dormer roof catches the sunlight, I add raw sienna to warm it. Where the roof goes out of the light, I add ultramarine blue. The roof color is touched into nearby trees, relating the color to its surroundings.*

STEP 6. *I now proceed as I would when proofreading a letter. I start at one corner and look methodically at all the edges. I want simplicity—without monotony. By running diagonal shadows across the lower part of the houses, I make them look less like boxes, and also create diagonal lines pointing into the picture. These cast shadows catch very little warm reflected light, and are cooler than out-of-light areas. How cool depends on the day and the nearness of the object casting the shadow. I'm careful not to overdo the darks, adding so many that the picture takes on a coolness inappropriate to the season. Spring is an in-between time, neither very hot nor very cold in color.*

DETAIL. *(Right) Here the rough-brush strokes follow the shapes of the various materials as defined by the light. The cast shadows on the foreground wall of rocks, for example, slant to the right. I avoided all hard marks earlier in the painting process; most hard edges would have interfered with later glazes. But now I use strong darks (ultramarine blue and burnt sienna) for the out-of-light and no-light areas. Notice that the marks are all varied in direction and size. Expressive brushstrokes, they keep the rocks from looking, as my friend Emile Gruppé says, like potatoes!*

DETAIL. *(Above) I use alizarin crimson, cadmium scarlet, and ultramarine blue for the out-of-light parts of the rocks. I work on the small bushes, remembering that because of the prevailing wind they tend to grow in one direction (toward the left, in this case). I try to feel the force of the wind as I work. The darks of the tree branches add snap to the painting. Notice that they're painted with a broken line. This line is visually more interesting than a solid dark line—and also more true. Light naturally spills across the bark, making it sparkle. Throughout this detail, rough-brush marks suggest the shimmering effect of light.*

DETAIL. *(Left) This last detail emphasizes the importance of graceful and rhythmic strokes when painting the branches of trees. Again, rough drybrush work suggests the sun's glare on trunk and branches. Even the leaves are applied rhythmically, in irregular groups. They swing down into the picture, and so serve a real compositional purpose. Notice also that I placed the branches in such a way that each section of the sky has its own special shape. They don't look like carefully cut pieces of pie.*

3. Light on Horizontal and Broken Planes

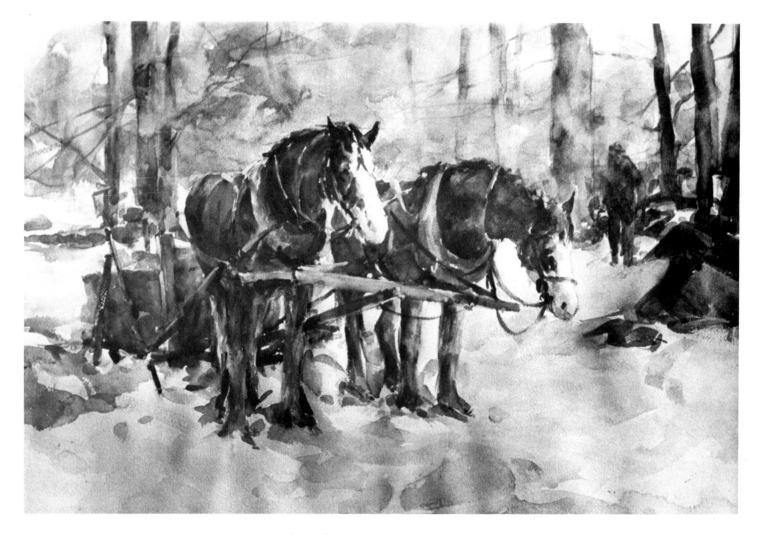

MAPLE-SUGARING, *15" x 22" (38 x 56 cm). In order to concentrate your attention on the two horses, I've killed the background trees (there's lots of snow in the air) and broken the area around the animals' hooves—that connects them to the snow and keeps their hooves from being too obtrusive. Although on such an overcast day the horses' heads would be fairly dull in value, I purposely let the white paper show, knowing that the contrast would attract the viewer's eye to my center of interest.*

This is a studio picture, developed from color sketches made on the spot. What particularly interests me in this painting are the forces of snow and ice that pushed the dory up from the shore and wedged it against the sea wall.

LIGHT. The day is overcast, with a break in the distant clouds. Light comes down the background slope and enlivens the area around the bow of the boat (my center of interest). The strong light in this part of the picture keeps the design from becoming too soft and quiet. The horizontal up planes in the foreground receive all their light from the warm, clouded sky. In the studio, I arbitrarily *chose* to make the sky red (it may have been much cooler in reality)—because I needed a warm note to balance the cool color in the snow and ice. Since the rock wall and boat are solid objects, they'll also be hard-edged. It's a cold day and a certain number of hard edges will suggest that there's been very little melting.

KEY. This is a middle-key picture, mainly played around middle C. There's a general lack of sunlight—and that rules out strong contrasts in light and dark. I go almost as light as I go dark, without touching black. The picture is thus a study in close values.

PAPER. The painting is done on Saunders 200-lb rough paper. It's a very soft paper—just right for this kind of a subject, since it absorbs color and naturally resists strong value contrasts. I also need

its rough-grained surface. I plan to use rough-brush marks to texture the distant trees and to soften the edges of the snow. In order to get a smooth wash on such paper, you have to apply a little extra pressure to the brush; you'll sense how much after a little practice. This is important, for I want to cover the paper in the early washes. Remember: white specks break up your light pattern and confuse your design.

PRELIMINARY SKETCHES. The preliminary drawing is very important in a picture of this sort; each plane takes a different value and color, and I want to know exactly where each is when applying my washes. In order to prepare myself, I often do a lot of on-the-spot sketches. In Figures 38 and 39, for example, I use a quick and convenient sketching method taught me by my friend Margaret Williams. The rough sketch is first blocked in with charcoal, then plain water dilutes the charcoal into a series of washes. Chinese white lightens values; extra charcoal sharpens an edge. I concentrate on the facts when doing such sketches—I don't worry about composition. Once I begin to understand a place, it naturally suggests compositional ideas to me. That's better, I think, than my trying to force a place into a favorite compositional formula.

In the preliminary drawings, I wanted to suggest the force of the wind and ocean. That's why I decided to paint the subject from the vantage point of the ice. I could have painted it on the bank; but I wouldn't have been involved in the material. This was the most expressive angle I could choose.

FIGURE 38. *Using charcoal, clean water on my brush, and Chinese white, I can make rapid on-the-spot studies of planes as they move in and out of the light.*

FIGURE 39. *I paint such subjects exactly as they are in nature; they're explorations of a spot, not exercises in composition.*

STEP 1. *I exaggerate the circular shapes of the snow drifts and the curved pattern made on the ice by the comings and goings of the tide. I'm impressed by these forces and try to make my brushstrokes mirror their effects. Movement comes first! I also place the boat high on the paper, to suggest how far nature has pushed it. You can see the area covered in its journey. Since the picture is dominated by horizontals and diagonals, I introduce the strong vertical rock on the right. It holds up the bank and gives the painting an added strength.*

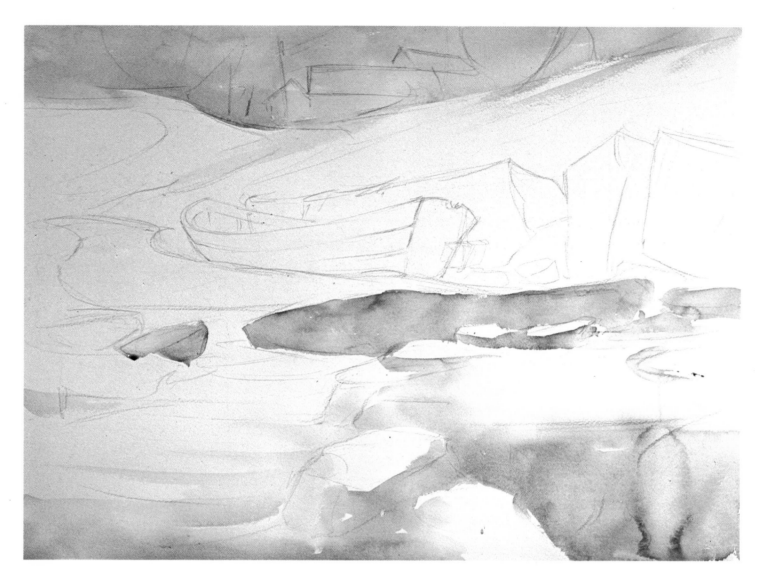

STEP 2. *I start with the broken piece of ice in the center of the painting (Winsor green, cobalt blue, yellow ochre, and lots of water). Since the ice is translucent, these out-of-light washes will be lighter and warmer than the out-of-light areas of snow. The ice darkens toward the top, where a layer of snow blocks the light; cobalt blue and light red indicate the decline in translucency. Alizarin crimson is used to darken the wash in the lower right and suggest traces of harbor mud. Note the softness of these edges compared to those of the broken pieces of ice. The sky is warm (yellow ochre and cobalt blue with cadmium scarlet predominating). The sky color touches the background snow, losing some of the edges.*

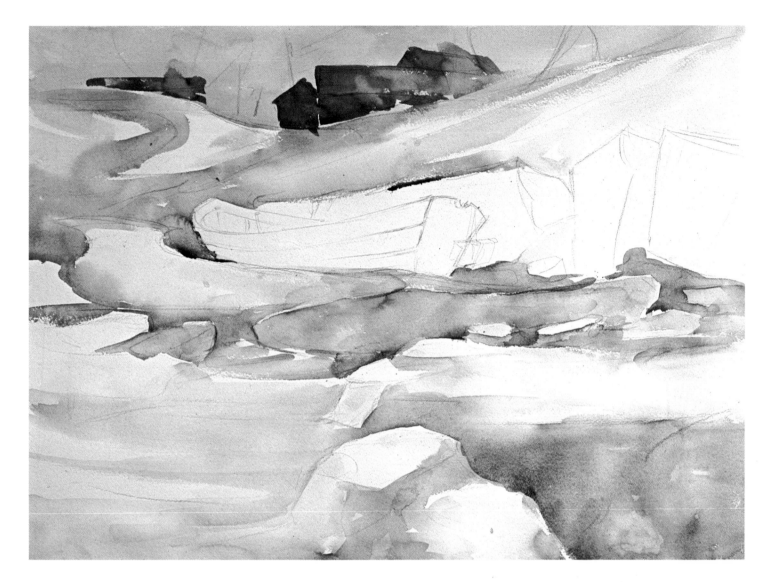

STEP 3. *I work up the snow, establishing the relationship between snow and sky before I add any real darks. I carefully preserve the whites, since they lead into the design like stepping stones. The grayish snow (yellow ochre and cobalt blue, with a touch of alizarin crimson) is applied with a swinging stroke, a stroke that expresses the effect of the wind. As the planes of snow become horizontal, they catch more of the warm light of the sky. I add more cerulean blue to the snow nearest us; the added color brings the snow closer by making it more exciting to look at. Within the snow washes, the edges are mostly soft, with some dark added to tuck the drifts under.*

DETAIL. *I model the snow bank, making it cooler than the ice—but not so cool that it becomes a "pretty" blue. I claim one sharp edge, where the sun hits the snow. The background houses are dark, but not so dark that they jump out at you. Some hard edges indicate the solidity of the houses; water is also thrown into the wash to lose a few of the edges. Yellow ochre and cobalt blue are used for the house nearest to us; light red and cobalt blue in the house farther back. I want a suggestion of color differences—not an unrelated collection of colored spots.*

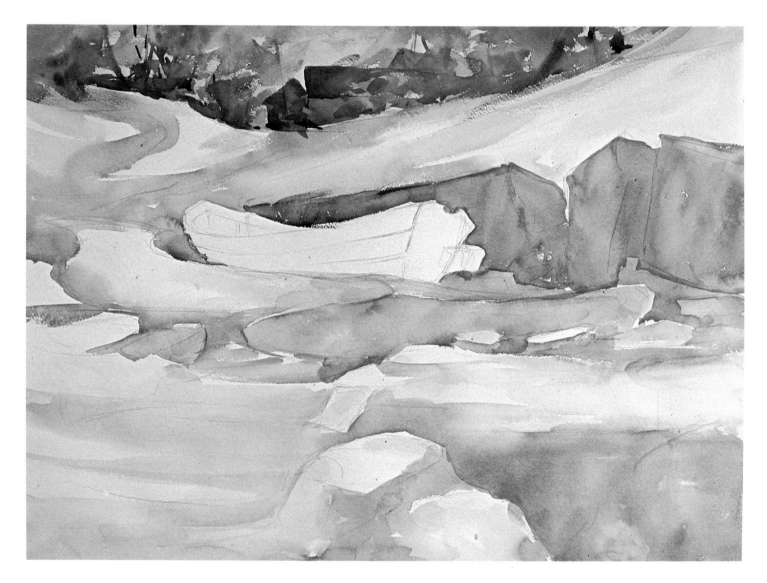

STEP 4. *I work on the wall and the background, still holding off on the no-light areas in the snow. The wall is painted with cobalt blue, raw sienna, alizarin crimson, and a lot of water. The face of the wall catches a lot of reflected light from the snow; it's therefore warm in color. The sides of the rocks, however, don't catch as much light, and are therefore cooler. Notice that the mass of the wall slants downward, thus leading your eye toward the boat. The trunks of the distant trees also angle inward, funneling the viewer's eye toward the center of interest.*

DETAIL. *I move to the background, working all over the paper and never finishing any one area. The tree trunks are painted first, with both wet and rough-brush strokes suggesting bare branches against the sky. You sense something is happening, but you don't see specific bushes and trees. Notice how the colors of the trees, houses, and snow bank are all closely related—the color ties the objects together.*

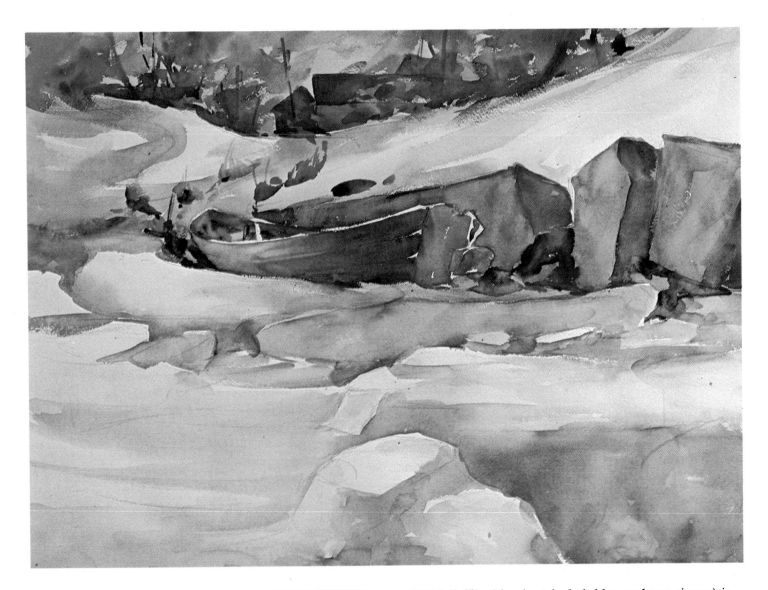

STEP 5. *The blue boat (cobalt blue and raw sienna) is the focal point of the design—everything leads to it. The boat is old and weatherbeaten, so I don't mix the colors too thoroughly. The strokes follow the direction of the boards that form the boat. I develop my out-of-light darks (cobalt blue, raw sienna, and alizarin crimson, with some light red added to vary the wash). The strong no-light darks at the bottom of the boat and the wall indicate where the snow and man-made objects lock together. Clumps of grass (raw sienna and cobalt blue) are suggested near the bow of the boat—they're just pleasant marks, rather than an attempt to draw each blade of grass.*

DETAIL. *As the blue boat turns, it catches a warm (cadmium orange) reflected light from the snow. The light bounce is strongest near the bow where the boat cuts sharply under. As the area sets up, I further lighten the wash. I also work on the inside of the boat. This area is a key color—it's rich, attracts the eye, and gives the whole picture a boost. I use light red and yellow ochre for the in-light color; light red and cobalt blue for the out-of-light side. I finish the area while it's wet, losing sharp edges and breaking up the wash. Perfection wouldn't suggest the boat's age and hard use.*

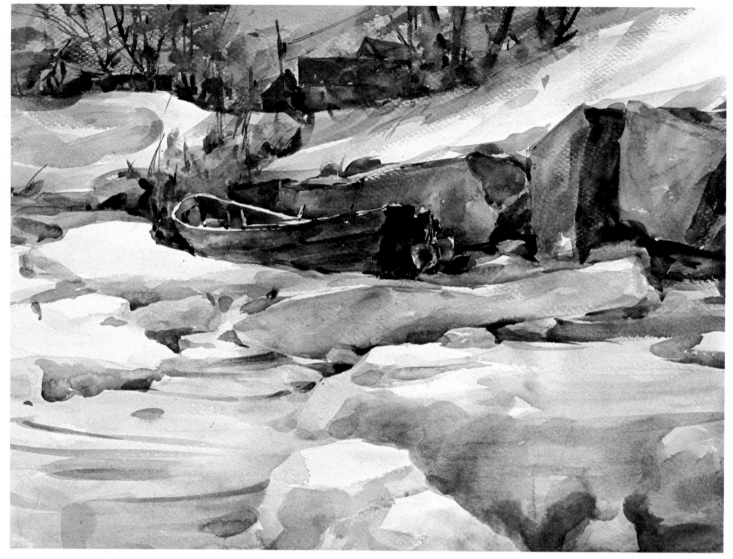

STEP 6. *Now that my darks are established, the large central block of ice looks too light; I glaze over it with a wash of cobalt blue, alizarin crimson, and yellow ochre. I paint the dark stern of the boat (raw sienna and ultramarine blue), getting the wash down and then dropping additional warm and cool color into it. I lighten the side of the boat (the first wash was too dark) and vary the edge where the boat and snow meet. I work dark, rhythmical marks over the foreground (cadmium scarlet and cobalt blue), emphasizing the effect of the tide; but I keep the marks from becoming too important by connecting them through both line and color to the out-of-light sides of the nearby drifts.*

DETAIL. *(Above) I concentrate my interesting shapes (grass, house, and trees) near the bow of the boat, my center of interest. The grass is painted simply, but it attracts the eye because it's a dark mass against a light one—and a warm color against a cool color (there's lots of cobalt blue in the out-of-light area between the clumps). These tufts of grass also connect the boat, wall, and background. All this visual activity draws the eye to the center of interest—without it, the area around the boat would be of no more interest than the wall directly to its right.*

DETAIL. *(Left) Rough-brush marks now help pull the painting together. I work over the rocks, the snow, and the ice—reducing the water in the wash and lessening the pressure on the brush so the color catches the surface of the paper. You can see how this breaks up the surface of the rocks and makes them look chipped and broken. Dark no-light marks show where the wall tucks under. To the right, a quick horizontal rough-brush mark softens one of these no-light edges. A hard edge so near the frame would attract attention from the center of interest. Notice that the snow washes are applied in a hit-or-miss fashion. The variety in color and weight of paint suggests where layers of snow overlap and move in and out of the light.*

4. Expressive Color and Edges

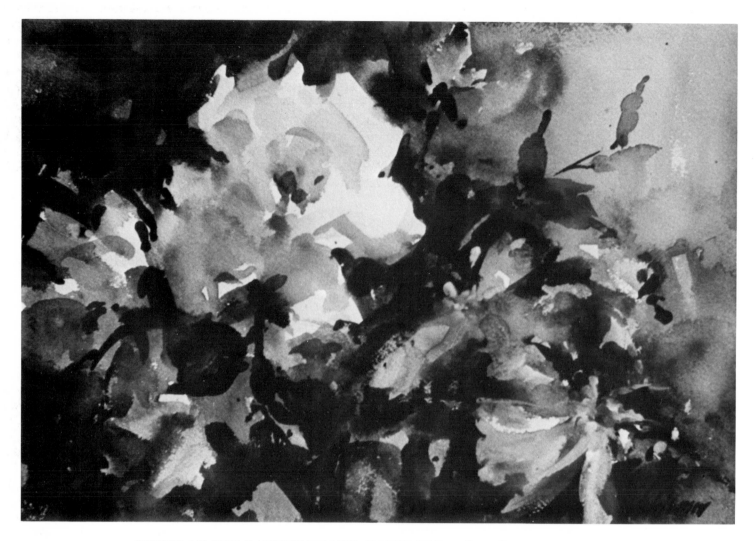

ROSES AT OLD GARDEN BEACH, ROCKPORT, *11" x 15" (28 x 38 cm). I always paint these roses in October. They've been hit by the frost; some of the flowers are fresh, some gone-by, some still in the bud. They're interesting because they all take on different shapes. By keeping the light high on the paper (with the full bloom and the bud highest of all), I make the flowers more vital. They seem to be standing up and growing. There are lots of broken edges in the picture; they suggest sunlit flowers blowing in the fall wind. The leaves are handled abstractly. You sense them without really seeing them.*

This is a fall bouquet and so contains lots of warm fall colors. I emphasize the reds and purples in the picture—the cosmos, the red leaves, and the red zinnias. To balance all this warm color and keep the picture from becoming too hot, I introduce a number of green and cool yellow masses.

LIGHT.

I placed the spotlight close to the bouquet and aimed it toward the upper part of the flowers. A light high on the subject forces the eye to move up into the painting; it's suggestive of life and growth. The cosmos are clearly the subject of the picture: they get the strongest light and are surrounded by the strongest contrasts in light and dark.

Because the spotlight is close, objects quickly move out of the light, as they do in *Jenny's Arrangement*, page 50. Object merges with object, and we get a lot of soft edges. Nothing could be more appropriate in a flower picture, for the essence of a flower is its softness and delicacy. That's one reason you have to be careful when working from artificial flowers—their edges are all hard and mechanical.

KEY.

Since our main colors—the reds and purples—are low in value to begin with, the midtones and darks in the picture will naturally group together, somewhat below middle C. They're not in the brilliant upper register; to get such sharp, clean notes we'd have to place lighter flowers, such as daisies, in the bouquet. With the midtones and darks close together, the lights will pop—thus drawing attention to the cosmos.

PAPER.

The painting is done on 300-lb Arches cold-press paper. Since the subject is a complicated one, I may have to make corrections. I plan for this possibility by using a tough paper, one that can take a beating.

PLANNING THE COMPOSITION.

I don't want the bouquet to be a hodge-podge of shapes and colors. There has to be *one* thought behind the picture. When I first looked at this bouquet, I said to myself, "What beautiful cosmos!" And that's what the viewer should feel when he looks at the picture. Therefore, I intend to work up the cosmos (my subject) most completely. The marigolds will be less developed; the zinnias and marguerites even less so. Similarly, the color will be played down across the picture, with the cosmos representing the most vibrant color area. Notice, for example, that the apples in the lower left-hand corner add to the red of the painting. But if they were in light—and therefore yellower and lighter—they'd draw attention away from the center of interest, the cosmos. I'm therefore careful to tuck them into an out-of-light area.

PRELIMINARY STUDIES.

It's very important to spend time studying and drawing the subject before you paint it. If you know the flowers well, you can paint them more freely, and they'll seem to live and move. I use various aids to help me draw the flowers, but the principal one is illustrated in Figure 40. Can you see how each flower begins with a few simple, elliptical forms? The roses on the left, for example, start as a cup shape; the oval indicates the plane of the flower, so I know which way they're facing. I can then add the petals. The lily and the daisies are handled in a similar manner. By first drawing geometric shapes, I immediately begin to think about the three-dimensional form of the flower—not the two-dimensional outline. That's important, for we're trying to paint light on form—not light on an outline! In the preliminary drawing, you can see how I use this approach when drawing the marguerites.

Form is also important when I draw the leaves. Notice, for example, that the leaves to the left in the preliminary drawing are thin and spiky, while those in the upper right are fatter and more rounded. Each must be drawn in a way that expresses its unique character.

Of course, when I draw I look for more than the shape of the individual flower. I'm really interested in the flow of the bouquet as a whole. I don't just place the flowers anywhere. Notice in the drawing that groups of leaves and flowers swing toward the center of interest. They curve up from the lower half of the drawing and down from the upper half. These lines form my main directionals.

These swirling lines and shapes not only direct the eye, but they're also appropriate to the subject. I avoid static, straight lines and instead play up the vital curving lines of living plants. Such lines make the bouquet very exciting to draw—much more so than a purely architectural subject.

Before starting to paint, I erase all unnecessary lines. Pencil lines will show through and dirty my light washes. Remember: we're always trying to say things in the simplest possible way. Unlike oil painters, who can build up the surface of their work, we watercolorists must draw in order to see what can be eliminated.

ADDITIONS TO THE PALETTE.

For this flower painting only, I add two colors to the palette: a cold, dark, Winsor violet and a warm, light, cobalt violet. I use these colors when painting certain flowers—*never* when doing a landscape. I could mix similar tones with my regular palette, but using color out of the tube is easier—and the color is a little brighter. This brightness is important to me; it adds to the freshness that I find so characteristic of flowers.

FIGURE 40. *By starting to draw flowers with a few simple geometric shapes, I immediately think about three-dimensional form rather than two-dimensional outline.*

STEP 1. *The subject calls for expressive exaggeration. I therefore play up the swirling lines of the bouquet in order to communicate my excitement to the viewer. I also exaggerate the color since, after all, the essence of a flower is its color. I'll exaggerate—but I won't be un- truthful. I'll be subtle, so the viewer feels my excite- ment, without noticing my strategy.*

STEP 2. *I start with the cosmos (nearest the light) and work through the picture in order of the degree of importance of each object. I get the color and value of the flower with the color changes that occur as it moves and turns from the main light. This is done while the wash is wet, thereby assuring clarity of color. Remember: if I work wash over wash, I'll begin to kill the feeling of light. The watchword is always: Lighter, brighter; darker, duller! The water in the wash gives the picture a feeling of air and also suggests the transparency of the petals. If the color looks wrong, I throw more water and color in the area while it's wet—sponging would only damage the paper. I don't paint flower by flower but, instead, work a color at a time through the entire picture, often thinking in terms of balanced, triangular arrangements of color spots rather than actual flowers. That's an easy and convenient way to think about color; from the first, it forces you to think about the paper as a whole.*

DETAIL. *The flowers are painted slightly bigger than they'll be in the final picture. Later I can refine the edges and cut the flowers to the right shape with the dark, surrounding leaves. The curved movement of my brush matches the shape of the individual petals. The in-light part of the cosmos is painted with cobalt violet warmed by lemon yellow. As the flowers move from the light, I use alizarin crimson and raw sienna to cool and darken them. I add cobalt blue to the background cosmos. Cobalt blue doesn't gray the violet (as would cerulean blue), so it pushes the flower back while still keeping the color fresh. The dark spot in the detail—the area where almost no light reaches (the no-light area)— is painted with Winsor violet and a bit of alizarin crimson. Placing the strong dark there tucks the flower under and gives it a rounded form.*

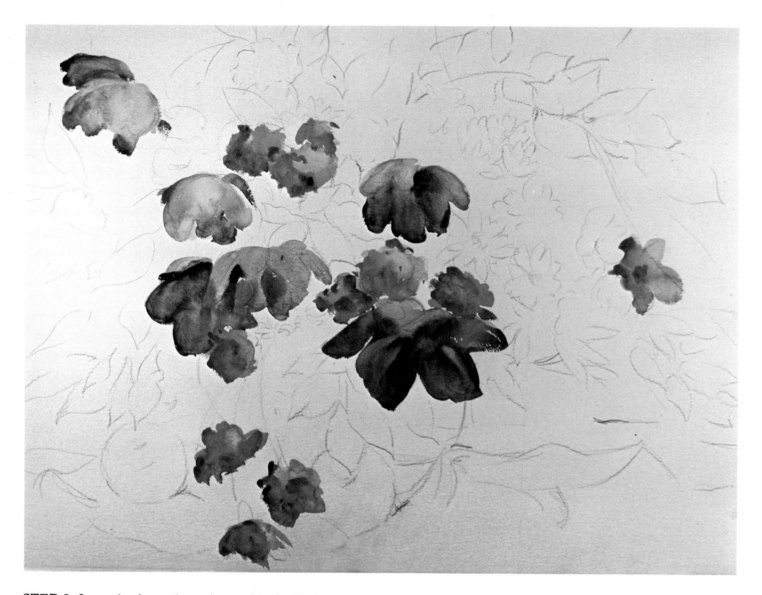

STEP 3. *I now begin work on the marigolds. (I clean my water of sediment every time I begin a different group of flowers.) Marigolds are a tight, clustered flower—less transparent than cosmos. Although I still use plenty of water, I increase the percentage of pigment, making the washes heavier in character. I keep the foreground flowers light, lighter; they're closer to the light and I want the other flowers to recede in contrast to them. I continue my triangular dispersal of color. Notice, for example, how a dot of color on the far right balances the design and keeps it from tipping to the left. At every stage, a picture should be in balance—so that if you suddenly stopped and never touched the paper again; it would still be a stable color arrangement.*

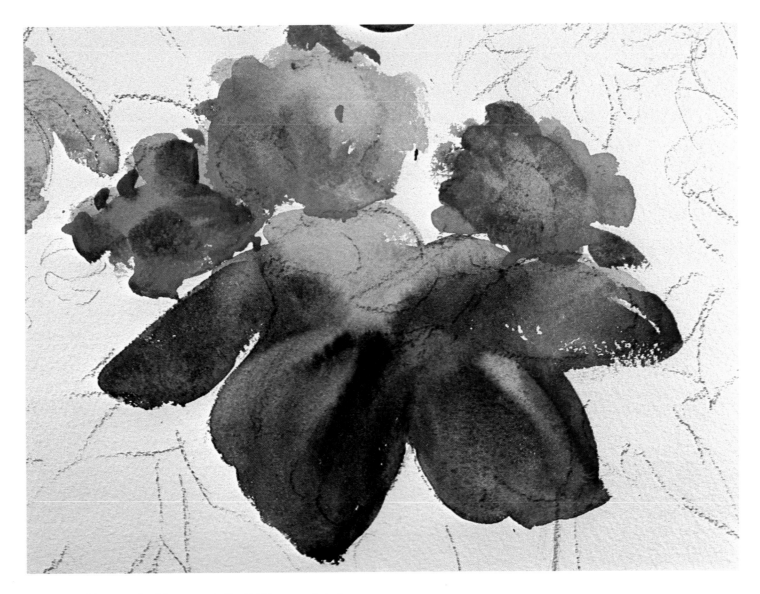

DETAIL. *The marigolds nearest the light are painted cadmium orange with a touch of cadmium yellow. As the flowers move away from the light, I take out the cadmium yellow. In the background, the marigolds are painted cadmium scarlet and raw sienna (both of which are cooler than cadmium orange). The addition of cerulean blue turns them from the light; cobalt blue and alizarin crimson take them out of the light. Notice also the large cosmos. It's probably the most important single flower in the whole bouquet—so I make sure it's as interesting as possible. Pay particular attention to the small, subtle touch of warm reflected light in its center. The warm color makes you feel you can look into the area.*

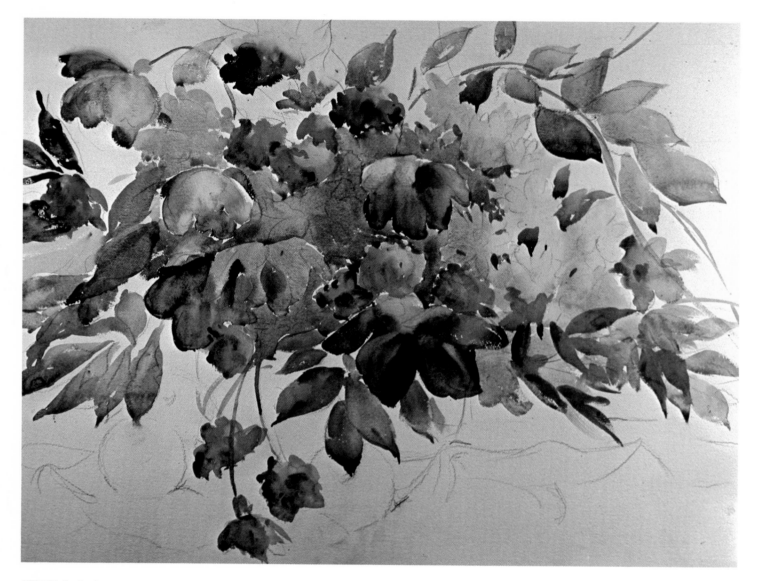

STEP 4. *I clean my water and begin to finish the rest of the areas in light: the marguerites, leaves, and zinnias. The zinnias are painted with orange and cadmium scarlet—a touch of cobalt blue softens the color and keeps it from being too bright. Notice that I sponged out a part of the zinnias at the top of the paper—they're crowded too near the frame. At this stage it's easy to change a shape—imagine how difficult the correction would be if I painted the background first, and then discovered that the zinnia was in the wrong place! That's why you should spot your color masses first—and then worry about the subsidiary areas.*

DETAIL. *Toward the top of the detail, the background leaves are suggested by a soft, warm wash of cobalt blue, yellow ochre, and a touch of cadmium scarlet. The leaves nearer the foreground are painted with raw sienna and alizarin crimson. You can see the interesting variety of color within these washes. The leaves look dark in the detail, but that's because they're seen against the white paper. They'll look brighter once the out-of-light background has been added.*

Since I'm using a lot of green in this picture, it's important to realize that, in watercolor, green is a hard color to handle. Few colors go muddy as quickly as green; and many painters aggravate the problem by using too many pigments when they mix their color. In order to assure color clarity, I try to use no more than two colors in any one green. For example, I mix lemon yellow with cerulean blue to get one sort of green, with cobalt blue to get another, and with ultramarine blue to get yet a third. The results are three distinct sorts of green, each mixed with only two colors. I can then gray each color with either cadmium scarlet or alizarin crimson. To get even more variety in my greens, I can also mix each blue with cadmium yellow, or with yellow ochre, or with raw sienna. Try mixing these colors for yourself so that you can get a sense of their markedly different characters.

DETAIL. *I paint the marguerites as a mass, not as individual flowers. In light, the marguerites are painted with lemon yellow and a lot of water. As they move from the light, I add yellow ochre, graying it with cerulean blue and cadmium scarlet. I have to be very careful when I gray a yellow by adding blue to it, as I do when it's in an out-of-light area; it's always in danger of going too green. A touch of cadmium scarlet keeps it from going green. I paint the vine next, since it's in a related color family. I claim the edge where flower and leaf meet, hardening it—then free myself to do the rest of the leaf more loosely. The closest, warmest leaves are lemon yellow and cerulean blue, dulled with a touch of the cadmium scarlet.*

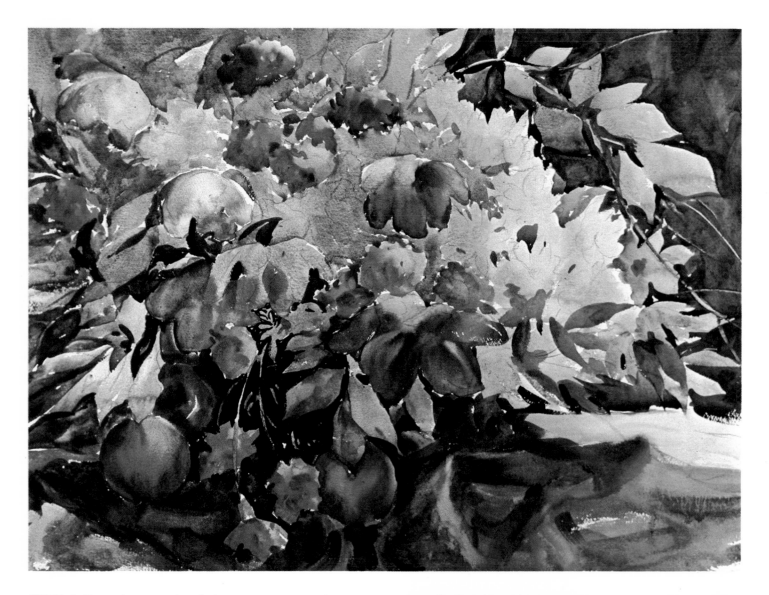

STEP 5. *Raw sienna and cadmium orange warm the foreground drapery in light. Cerulean and cobalt blues soften and gray the drapery as it moves from the light. I exaggerate some of the out-of-light darks in the folds; they lead the viewer's eye into the picture. The background drapery on the upper left (painted light red, yellow ochre, and alizarin crimson) is farther from the light and therefore less warm. Touches of cerulean blue break up the color of the drapery and suggest folds and shadows cast by the leaves on the cloth. I glaze the background color over some of the nearby marguerites, dulling them so the other lights will pop. The dark drapery on the upper right-hand side is painted with burnt sienna, raw sienna, and cobalt blue. Touches of alizarin crimson add interest to the wash.*

DETAIL. *I add some very dark, no-light touches (ultramarine blue, alizarin crimson, and burnt sienna), varying the amount of water so that some darks are opaque, while others are more transparent—you feel there may be a little light hidden deep within some of them. These variations help you penetrate into the bouquet. I'm more interested in the flowers than the leaves, so while I treat the flowers realistically, I handle the leaves in a more decorative, stylized manner. Notice how the different colors used in the leaves have all dried at different speeds, creating unusual textures within the wash.*

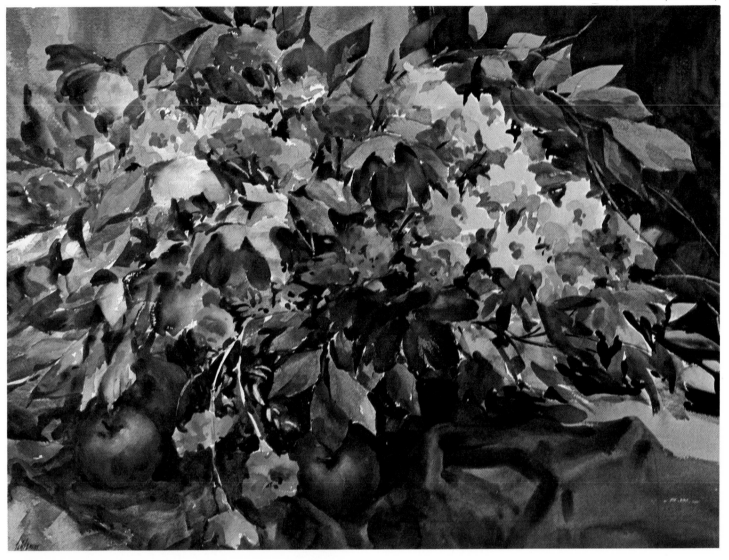

STEP 6. *I add more darks and an occasional glaze to quiet the color in a subordinate area. I do most of the accenting in the center of the painting, where I want the eye to look. Here and there, I add a stem or a glisten by wetting the paper, waiting for the water to lift the color, and then by scraping the area with the handle of my brush. Notice the edges. The edges on the upper right, for example, are hard because they catch a strong blast of light. Those on the lower left are soft. They're out of the light and the value contrasts are therefore much less marked.*

DETAIL. *I model the marguerites, taking particular care to watch the outer edges (their characteristic shape). I darken a few centers, so that the mass feels like flowers. Notice that the darks within the centers of the marguerites are warm. The petals are translucent and the area catches a lot of reflected light. There are no cold out-of-light areas in this flower. If you'll review the previous steps, you'll notice that I never finish one area before another. I work all over the paper. It could be said that all parts of the picture are always at an equal state of "finish"—after ten, twenty, or a hundred strokes.*

5. How White is White?

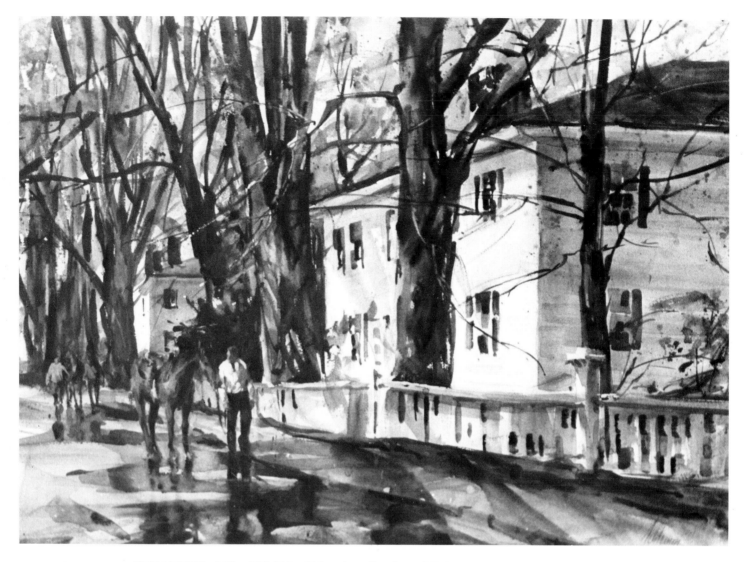

CLEARING, 22" x 30" (56 x 76 cm), collection of Edward and Elizabeth
Schlemm. I was struck by the old trees and the even older New England house.
The large trees helped add to the feeling of age; and their branches conveniently
broke the edges of the building, adding variety to what might have otherwise
been an excessively square shape. The fence is in the old New England style—
this detail is characteristic of the region. I always enjoy talking with townspeople
before painting an area—just so I can learn about such local customs.

In this demonstration, we'll look at the light on a completely overcast day and examine the question of just how white is white—a problem many students have when they deal with white areas not directly in the light.

LIGHT. The light on a gray day is similar to that at high noon. It's a diffused, relatively colorless light. The atmosphere is heavy, and veils of moisture *neutralize* the warmth of the sun, actually causing the source of light to take on a cool coloring. As you recall, whatever the color of the in-light areas, the out-of-light areas naturally take the *opposite* color temperature. In this case, therefore, they will be warm. If the day were slowly to clear, the dissipating moisture would let more and more sunlight shine through. The in-light sides of the houses, now catching a bluish light, would start to warm up. As the day became "hazy," these in-light areas would be warmer still. And when the full sun came out, we'd be back to the normal sunny day of the second demonstration—with warm in-light areas and cool out-of-light areas.

THE WET-IN-WET APPROACH. Since the light is cool but not strongly colored, we don't need to do much glazing—we won't have color shining through color. Instead, I decide to use the wet-in-wet method. It's not a method I use very often. But it's one you should be familiar with. It can be very useful, especially with a subject like this one: the soft edges characteristic of the method perfectly match the soft edges of a gray, wet day.

To prepare the paper for wet-in-wet painting, first wet it three times on each side with a soft, natural sponge and place it on a Masonite board, cut slightly larger than the paper. (If the edges hung over the edge of the board, they'd dry before the rest of the paper.) If the paper buckles and shows air bubbles, you haven't wet it enough. Drop more water between the board and the back of the paper—if you keep adding water as you paint, you can keep the paper wet indefinitely.

Don't tape the paper to the board! The wet paper adheres naturally and, as you paint, will continue to stretch for about a half hour. When it finally lies flat, go over the paper with a soft, natural sponge, both horizontally and then vertically. You can start to work on the paper as soon as the glisten leaves the surface. If you want an area to dry more quickly during the painting process, use tissues to pick up the excess water—not rags. Once the paper has begun to dry (after about a half hour), apply four clips, two on the right and two on the left-hand side of the paper near the top and bottom. They place the paper under an even tension and keep it from buckling.

KEY. This is a low-key day, with few strong contrasts—there's no bright light to create them! I won't use either brilliant whites or deep blacks.

The lights and midtones cluster a little above middle C; the darks are farther down the register. Because the interval between the darks and midtone values is greater than that between the midtone values and the lights, the darks naturally pop. This is appropriate for the day (on a wet day, the darks are usually rich in color) and also gives us a nice dark compositional pattern. In Figure 41, you can see how light the sky, water, and houses are on a gray day; they form a simple pattern, accented by a few strong darks.

PAPER. I use Arches 140-lb cold-press watercolor paper. It's a paper that has a good surface and can really take a beating; it needs strength to stand the wetting and sponging of the wet-in-wet method. The fairly textureless cold-press surface is also useful since, unlike in the third demonstration where I painted snow and ice, I don't want a lot of rough brushing in this picture—such strokes would suggest a shimmer that is inappropriate for the dull light of the day.

PLANNING THE COMPOSITION. With an architectural subject, getting things right is important; I therefore do a careful preliminary drawing. I first concentrate on the shape made by the piece of road and sky (accented in Figure 42). These are the first shapes you see when you look at the picture, and they're just as important as the details of houses and trees. In the preliminary drawing, I don't give much space to the street. It isn't important in itself; what counts is my ability to get you to feel as though you can walk down the street, into the picture.

I emphasize the expressive height of the New England houses by keeping the horizon low. Together with the tall elms, the houses create a dominance of vertical lines. Interest is added both by the diagonals of the street and the tree branches and by curved lines like those that break the edge of the house on the left.

When drawing a street scene, I usually stand to one side of the street and look either up or down. I try to show *both* sides of the street, thus creating an interesting shape, a shape that naturally leads into the picture. When you paint looking directly across a street, there's a danger that the house and sidewalk will form a parallel series of boring horizontal bands.

Notice that the large house to the right of the drawing frames the composition. The smaller house to the left is interesting in contour—but not so interesting that it attracts attention. The real focus of the painting is near the center, where houses and trees come together.

The drawing is quite strong, with added accents reminding me where I plan to place my darks. I'll sponge a lot as the painting proceeds and so want the drawing to be dark enough to take such abuse without washing away.

FIGURE 41. *As you can see from this quick pen sketch, on an overcast day values are close together.*

FIGURE 42. *This sketch is typical of the notes I make before beginning a watercolor. I've accented the all-important shapes made by the street and the sky.*

STEP 1. *The trees are varied in thickness and in the pattern of their branches. They're placed near the center of the paper, but more to the right than to the left. The street and sidewalk are a unit, and in drawing them I try (1) to keep the vertical edge nearest us from cutting the paper in half and (2) to prevent either side of the street from shooting directly into a lower corner (that's always very distracting, since, with the frame, such a line acts like an arrow pointing out of the picture).*

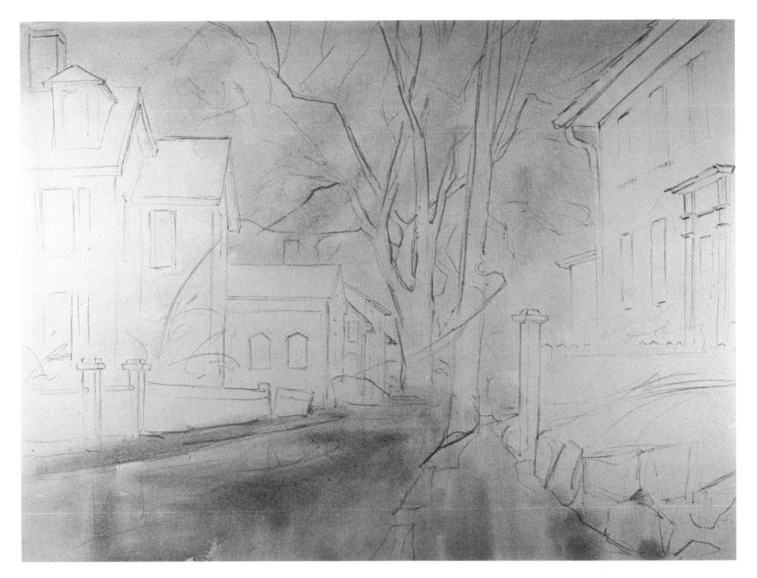

STEP 2. *I go for the most subtle relationship first: the sky against the houses. As in the previous demonstrations, I study this relationship before putting any real darks on the paper. The soft gray of the sky (cerulean blue, cadmium scarlet, and a touch of yellow ochre) is painted right over the trees. The colors break up in the wash, giving me a feeling of air. The wet macadam road reflects the sky color, though in a darker value. Yellow ochre adds variety to its color, while my brushstrokes suggest the vertical movement of reflections. Notice that although this is a gray day, my grays have light and therefore color—I'm not painting in black and white.*

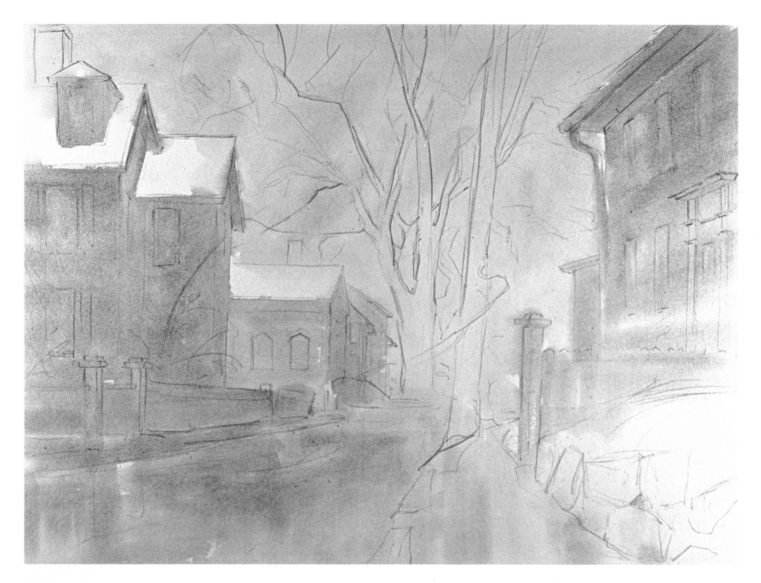

STEP 3. *The house on the left (cadmium scarlet, cobalt blue, and yellow ochre) is painted with strokes that follow the direction of the clapboards. I add cerulean blue to one side of the house. I add alizarin crimson to the wash when painting the house on the right; it's positioned differently and so catches a slightly different kind of light. I don't paint the edges of the houses till the sky has lost some of its glisten—otherwise, the washes will run. Notice that although the values are close, the out-of-light sides of the white houses are obviously darker than the sky.*

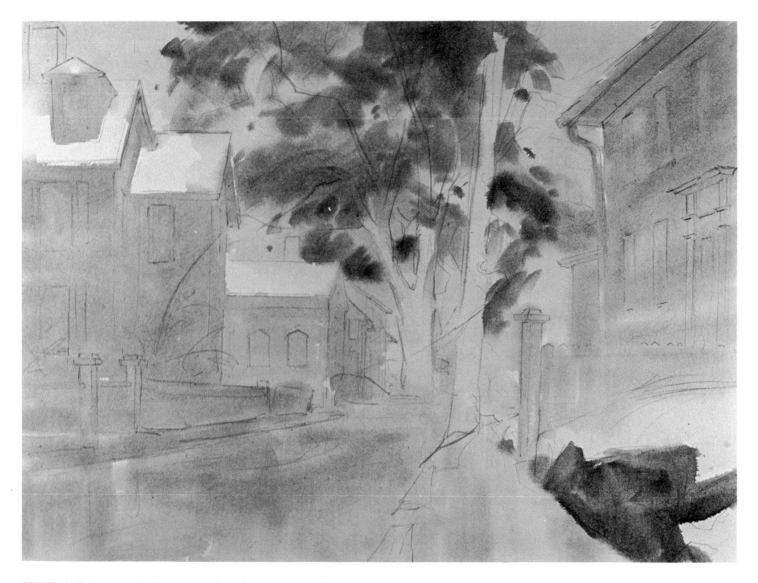

STEP 4. *I have to be fairly careful with the tree; it's a large, dark shape, one you'll notice when you look at the picture. Once the sky is set up, I use cerulean blue and touches of lemon yellow for the first wash; it represents background leaves catching some of the cool, diffused light. Yellow ochre and cerulean blue are worked into this wash, suggesting the darker leaf masses nearer to us. I add punch to the foreground by putting in some dark rocks (raw sienna, cobalt blue, and yellow ochre). Once the basic wash is down, I use a thirsty brush to lighten areas, picking up pigment to suggest different planes catching the light.*

STEP 5. *Cerulean blue is added to the dark roof (ultramarine blue, yellow ochre, and cadmium scarlet) to suggest where it's touched by the sky. Yellow ochre is added to the warm side of the house on the left. The foliage angled toward the source of light is cool, but it gets warmer as it turns from the light (raw sienna and cobalt blue). I paint masses rather than individual leaves. Much of the original cool green wash peeks through these darker colors. I continue to work my greens around the paper: from the big tree, to the foreground grass, to the small fir on the left. The distant greens have soft yellow ochre in them; the nearest, a rich raw sienna. I also add darks to the foreground (ultramarine blue) in the no-light areas.*

STEP 6. *The out-of-light tree trunks are alizarin crimson, ultramarine blue, and burnt sienna, with Winsor green and cadmium scarlet used for a few no-light accents. I paint the trunks dark first—then add water to break up the wash. I soften the trunks as they disappear under the leaves. Toward the top of the nearest tree, a rough-brush mark suggests a glint of light on the trunk. I paint the reflections when painting the trees; they're both part of my dark pattern. The cadmium scarlet roof (center) warms a picture that is in danger of becoming too cool. It's wet and so reflects some sky color (cerulean blue). The red is related to the rest of the picture; notice in the chimney in the upper left and on the bush behind the fence on the right.*

STEP 7. *I continue to develop my dark pattern, adding
shrubs and dark reflections in the road. I also suggest
openings in the houses, making them look like windows
and doors, but working at the same time for interesting
shapes. The picket fence is an area of "entertainment"—
the carefully painted parts explain the simpler areas. I
begin to use line to pull the picture together, just as I
used rough-brushing in the third demonstration, when
painting snow and ice. You can see the line in the fences
along the road, and along the roof of the house on the
right.*

DETAIL. *(Above) The puddle (ultramarine blue and raw sienna) is painted with different weights of paint. There's more pigment in some places, more water in others. The edges are also varied. Near us, we look over the water and it has a hard edge. Farther back, a soft edge lets us look into the puddle. Rough-brush marks in the center and on the lower left suggest a slight shimmer.*

DETAIL. *(Left) In this detail, you can see how the wet-in-wet approach breaks up the color and gives me a wonderful variety of soft edges. The paper has begun to dry now, so I clip it to the board, assuring an equal tension across the paper's surface. The blue-green house at the end of the street is a nice color spot. It helps attract your eye. But notice that it's not the same blue-green as the foliage. Everything has its own color— without the color jumps being so marked that the picture becomes a jumble of multicolored spots.*

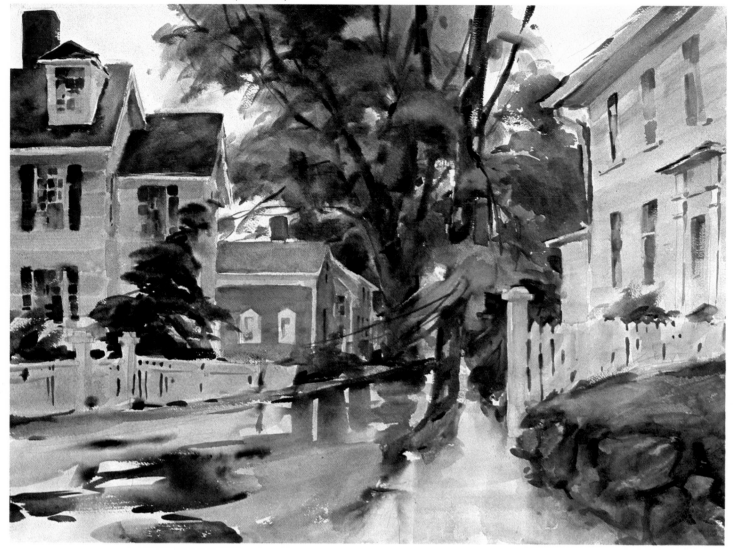

STEP 8. *Color still rests on the surface of the wet paper, and so corrections are easy to make. The roof on the left looks too light—so I throw in more color. I wash out the lower right-hand corner and make the rocks more effective. The fence on the right is too near the color of the sky, so I tone it down, using diagonal strokes to suggest a shimmer and to make the area interesting. I glaze over the foliage directly above the fence, leaving some of the lighter underpainting. The resulting edge pulls the area forward; you feel that one mass of leaves is in front of another. Alizarin crimson and yellow ochre add definition to the macadam road. Cerulean blue reflects into it, as it does on the foreground grass and rocks.*

DETAIL. *(Above) The dark fir and bushes all angle in a way that leads you down the street. The windows are varied in size and shape, but they're still true to New England custom. There's sky color reflected in the windows, hard and soft edges, and no-light darks (so you feel you can look into the house). I also try to get variety in the shutters so they wouldn't look as if they were stamped out by a machine. Notice that they're darker toward the top of the house—reflected light from the ground can't reach up that far.*

DETAIL. *(Left) The dark swirling tree branches connect sections of the picture, locking them together like parts of a jigsaw puzzle. Notice that I've kept a few patches of white paper near the center of the detail. These lights are very important. They attract the eye and assure that the viewer will want to walk down the street. They add mystery; the viewer senses that there's something behind the trees, that the street doesn't lead to an impenetrable black wall.*

6. Light and Movement

BASS ROCKS, GLOUCESTER, *22" x 30" (56 x 76 cm), collection of Dr. Kenneth Garrison. This is a surf study, done on the spot. I was interested in the brilliant light and the way it fell on the moving water. Luckily, the two figures arrived just as I began to feel the need for a spot where the eye could rest from all the explosive action.*

Now let's look at a spring day by the seashore. The storm is over; the sun has just come out. And since it's the kind of day that I like being outdoors, I'll try to get that feeling of exhilaration in the final painting.

LIGHT. The light in the painting is clear, but the active surf throws lots of spray in the air. I can't paint the moisture, but I *can* show how the spray affects the light, softening all the edges.

KEY. The midtones and lights are close together, spreading from above middle C to a few brilliant notes in the highest register. Foam and moisture in the air pull the values together. There's a great jump downward to the darks in the picture. I want these darks to sound in the final painting—like the notes of a bass drum! These terrific light/dark contrasts add to the excitement of the day.

PAPER. I use Schoeller 140-lb rough paper. It has a very, very hard surface. The paint doesn't sink in, and you can easily sponge down to white paper. That's important, for the water in a surf should be as fresh and clean as the petals of a flower. The color should sparkle—even in the spots where I've had to make corrections.

PLANNING THE COMPOSITION. The rocks are placed first—they're the bones under the skin, the body under the hanging robes. If you understand the rocks, you'll understand why the surf acts as it does. It's like spending time in life class. By studying anatomy, you learn to make sense of the seeming chaos of the human form.

You should do many on-the-spot studies of both rocks and waves. Figure 43 is one example of countless sketches I've done outdoors (I discussed the method used in the third demonstration). It's a reference study of two waves in a soft light. It's done quickly, as surf studies have to be. Figure 44 is an example of a more intense, careful drawing. Rocks stand still, so you can take more time studying them.

In order to keep the surf moving, I use lots of active, contrasting diagonals. The ocean and waves, for example, angle downward into the picture, while the line of the rocks slashes across the picture in the opposite direction. (If the scene were a peaceful one, I'd use more static horizontal lines.) Notice in the drawing that the big wave is the center of interest; the eye then follows the wave as it crashes over the rocks and into the foreground pool. The swirling lines in this pool direct the viewer's eye to the right and left, curving back to the burst of foam. The motion is thus a circular one, a motion that suggests, to me at least, the endless activity of the ocean.

I also emphasize the long line of the rocks across the middle of the paper. These long horizontals suggest an expanse of space far beyond the limits of the frame. This feeling of spaciousness is an important part of your experience of the seashore.

Although two-thirds of the picture is rock and water, the sky remains a large piece—too large not to share in the excitement of the day. You can see the active pencil lines in it. I've indicated some horizontal movement in the sky near the horizon: these low stratus clouds give the eye a quiet place to rest after the activity of the other parts of the painting.

FIGURE 43. *Rapid seaside studies can help you to understand the motion of the ocean and waves.*

FIGURE 44. *Since rocks stand still, you can take time to make careful studies of them.*

STEP 1. *The painting has a lot of strong rocks in it, and I'll suggest this strength through hard edges. Too many hard edges, however, would make the picture stand still. So I have to balance this need for strength against an equally important need for softness. I keep the drawing to a minimum. It tells me where I'm going, but also gives me a chance to work freely with the paint.*

STEP 2. *Since I can't paint the whites in a watercolor, I use the out-of-light parts of the surf (yellow ochre, cerulean blue, and cadmium scarlet) to help me visualize what these whites will look like. They're very important parts of the composition and I want to make sure they have interesting shapes. The heavy, opaque colors dry at different rates; they separate in the wash and create interesting textural effects. I get variety in the grays by using more yellow ochre, for example, in the churning foreground pool. Such variation suggests activity, without my needing to draw what's going on. My brushmarks follow the direction of the surf. I may lose some of the marks later, but they'll be felt under the glazes and will help keep the surf moving. Notice that the washes darken near the bottom of the surf, where the water turns from the light. The watermarks suggest additional activity in the surf.*

STEP 3. *I erase the pencil marks from the sky; if I tried to remove them later, I'd lift my color. The clouds are a gray made of yellow ochre, cerulean, and—for variety of color—alizarin crimson. I first claim the edge where sky and surf meet, losing parts of it and accenting others. A hard-edged burst of surf would look like a powder puff. I then work freely into the sky. While the clouds are wet, I add the color of the sky. Cobalt blue is at the zenith; cerulean blue, farther down; and cerulean blue and Winsor green, near the horizon. At the horizon itself, I add a touch of cadmium scarlet, a hazy, rosy color that pushes the sky back a good twenty miles.*

DETAIL. *Sky color reflects onto the water. I'll later pull the blue ocean over it. Watermarks texture the clouds to the far left—I liked them, so I left them alone. Notice how the sky color is breaking apart. Some students worry about "perfect" washes and are shocked when their colors begin to separate. They nervously try to brush them back together. Don't worry about perfection—worry about light and air!*

STEP 4. *I wash in the big rock areas with yellow ochre, cadmium scarlet, and cobalt blue. The cool cobalt blue takes the hotness out of the color. The pigments are heavy in the wash, so I can later use water to lighten areas—without the water diluting the wash back to white paper. There's more yellow ochre in the in-light parts of the distant rocks, with cerulean blue added where they turn from the light. I use more cadmium scarlet to bring the rocks on the far left nearer. I add raw sienna to the foreground rocks; the strong color also pulls the area forward. Notice how some of the color reflects into the water. The rock washes are messy— they help express the character of the subject.*

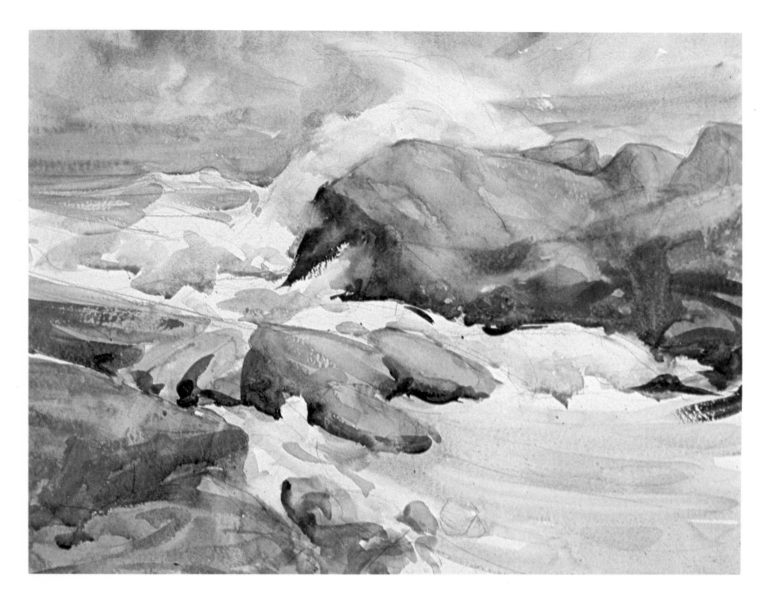

STEP 5. *The out-of-light and no-light areas of the rocks are made with varying mixtures of burnt sienna, ultramarine blue, and Winsor green. Cadmium scarlet sometimes warms the mix and suggests light sneaking into the crevices. The rocks are wet and dark near the water (ultramarine blue, burnt sienna, and Winsor green). I think of these darks as directionals first, and as "rocks" second. Notice, for example, how the darks on the far right swing around and back into the picture. The out-of-light darks in the flat center rock also lead you up and toward the crashing surf.*

DETAIL. *The dark near the center of interest is the most important edge in the painting. It has to be strong—yet also touched by mist. I therefore vary the edge. It's hard near the water, but softened by a rough-brush mark and actually broken by added water near its top. There are two kinds of light in this area: cobalt blue—representing the skylight—bounces into the dark from the nearby water; yellow ochre suggests the bounce of light from the sun. A rough-brush mark adds texture to the foreground rock.*

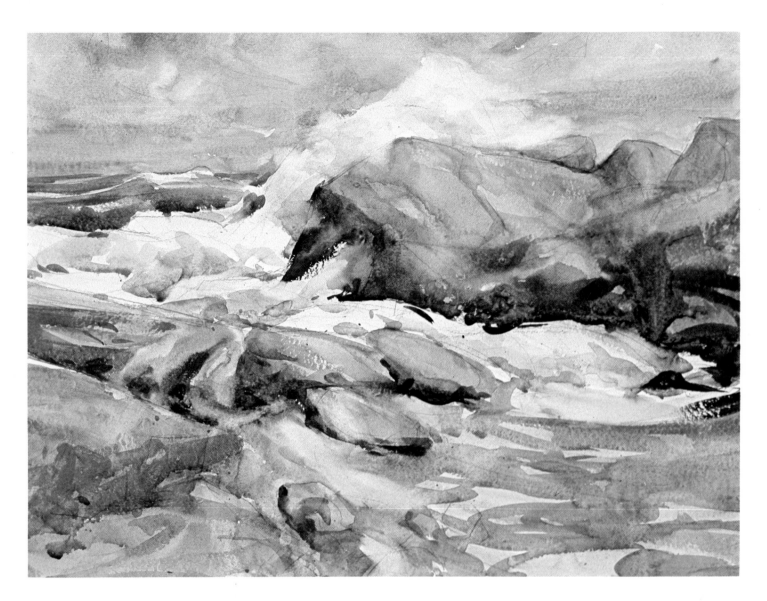

STEP 6. *The burst of foam seems too violent in its motion. I hate to touch, and thus dull, the sky, but I feel the correction is essential. I also soften the edge of the boulder to the right of the burst of foam (notice the amount of cerulean blue sky color in the out-of-light areas). Using cobalt blue and touches of cadmium scarlet and yellow ochre, I bring the wave into relief by painting the background water. I break the horizon, preventing it from becoming a hard, distracting line. I put more yellow ochre in the mix and accent the lively, churning action of the foreground water. I also darken the water on the lower left, obscuring the edge where rock and ocean meet. I don't want strong contrasts in a subordinate area.*

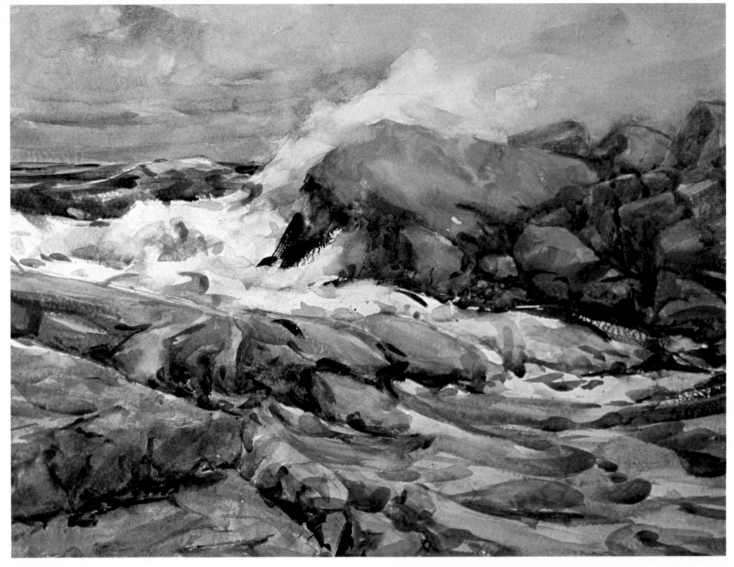

STEP 7. *I add darks to dramatize the picture, glazing dark washes over some of the rocks and working up my out-of-light and no-light areas on the right (ultramarine blue, cadmium scarlet, and burnt sienna). The accidental marks in the wash suggest shapes to me. I also sharpen nearby edges and further accent the circular motion of the tidal pool. These foreground swirls are painted with a big stroke. Notice, however, that I use a number of small strokes, too; they add variety and also move the eye into the picture.*

DETAIL. *The ocean is clearly swelling over the rocks— to paint it, you have to understand how underwater rocks are formed. As the water rises, it catches the light (yellow ochre—the light—warms Winsor green—the water—while a touch of cadmium scarlet grays the mix). The foreground cracks where rock meets rock are the only true no-light areas in the picture (ultramarine blue and burnt sienna). Almost everywhere else, reflected light manages to find a way in. Notice how some edges near the water are soft, others hard. Mist or spray naturally affects these edges. You have to show this effect— or the viewer will feel as if a piece of plate glass is separating the rocks from the water!*

DETAIL. *The stroke in the distant ocean and in the out-of-light foreground all express the churning character of the water. In the center of the detail, you can see where ocean and air mix together, forming a patch of light green water (Winsor green and a touch of yellow ochre). Notice the variety of strokes and how, in themselves, they suggest the textures of rock and water. The small darks move rhythmically around the center rock. They were placed with the same care I used when painting leaves in the street scene, "Light on Angular Surfaces."*

7. Flickering Light

MARCH 1: ROCKPORT, *22" x 30" (56 x 76 cm). In contrast to the following demonstration, where a flickering light softens and breaks edges, this is a painting of a harsh March day, a day low in color—strong, vital, and unsettling. The pronounced verticals of the trees and grass further strengthen the design, as do the big value contrasts. There's no room for delicacy in this picture—I want you to sense that it's a bad day to be outdoors.*

Wind and clouds give a feeling of moving, flickering light to a scene. When I paint the following demonstration, I'll try to capture the lively feeling of summer, the season when you want to go out and *do* things.

LIGHT. This is a summer day with a brisk breeze. In order to suggest the shifting, moving light, I use a lot of broken edges, trying not to latch on to individual objects. They'll be an important expressive element in the painting. When there is an edge, it will be fairly crisp.

KEY. The values cluster around middle C, with few bright lights or real darks. Such a key fits the old, weathered character of the barn. I'll get excitement within this restrained key, however, by using decorative marks to suggest the dappled light.

PAPER. The picture is painted on Saunders 200-lb rough paper. It's a soft, absorbent paper that automatically quiets my dark washes.

PRELIMINARY SKETCHES. Before painting the farm, I explore the area through a series of quick color sketches, no more than 6″ x 7″ (15.5 x 18 cm)

in size (Figures 45 and 46). In Figure 45, I found the composition had too much uninteresting foreground, a fact I'd hate to discover after doing a full-size watercolor! Similarly, I knew I had a good idea in Figure 46, but I also saw that it wasn't a stable design. In the actual painting, I added the horse and man as balancing elements.

PLANNING THE COMPOSITION. The final drawing isn't very elaborate. I want to be free to experiment as I work. I put in a lot of sky, for that gives the painting air and a feeling of the outdoors. As in the previous demonstration, the sky will also contribute to the excitement of the day. Notice, also, how the diagonal movement of the clouds acts as a foil to the dominant verticals and horizontals of the trees and buildings.

The trees are grouped in uneven units—three to the left of center, one to the right. As already noted, the man and horse balance the mass of the building and help keep your eye in the picture. I try to make the figure move by drawing him off-balance and by using curved, relaxed lines. These lines make him look like a living person, not a stick figure.

FIGURE 45. *A rough color sketch done on bristol board. By massing in the design, I could see that my foreground was lacking in interest.*

FIGURE 46. *Here the idea looked good—but I needed to add something to keep the viewer's eye from shooting out of the right-hand side of the picture.*

STEP 1. *Strong verticals and horizontals interlace, like material in a carpet. They hold the picture together. The angularity is relieved by the diagonals of the roof and sky—and by the rounded movement of the masses of foliage. Before starting to paint, I erase the pencil lines from the sky. They helped me determine how the sky will look, but I don't want them showing through the later washes.*

STEP 2. *The saplings are painted with yellow ochre, alizarin crimson, and cobalt blue. In the big tree, the stronger, deeper raw sienna replaces yellow ochre. As the large tree turns from the light, I cool the color by adding more cobalt blue and a touch of light red. The foreground logs are directionals, pointing the viewer into the picture. They're connected to the foreground post which, in turn, is connected to the big tree. The objects are unified by the light, rather than isolated by it. I also paint the similarly colored roof, horse, and man. Where the roof turns toward us, it catches a lot of warm reflected light.*

STEP 3. *I begin the sky early, for it determines the quality of the light. I wet the sky in a hit-or-miss fashion; that way, I'll get both hard and soft edges. I want "pop" in the sky as well as in the landscape. I cover the whole sky with cloud color (yellow ochre, alizarin crimson, and cobalt blue) and then add sky color, as in the previous demonstrations. The sky patches point the viewer toward the barn and trees. I don't overdo the sky; if the washes get heavy, I'll lose the all-important feeling of air. Remember: a landscape without air is like a body without bones!*

DETAIL. *Note that I pull the sky right into the mountains. Later, I'll paint the mountain tops and let the sky color suggest mist in the valleys. Notice, also, how the same reddish color appears in the figure's jacket and pants. The color ties the figure together and prevents him from becoming a bunch of different color spots.*

STEP 4. *I set the buildings into the ground by avoiding a hard edge there. The barn is painted with cadmium scarlet, cobalt blue, and a touch of yellow ochre. Raw sienna is added to what will eventually be the dark sides of the building; it's a vibrant color and suggests that reflected light bounces into these out-of-light areas. The distant in-light grass is painted with cadmium scarlet, lemon yellow, and cobalt blue. The color is also used behind the barn, where it suggests background trees catching the light. As the grass moves to the left (away from the light) I use a cool red (alizarin crimson) to gray the color. In the immediate foreground, however, rich, strong cadmium yellow is added to the mix. It pulls the area forward.*

STEP 5. *As in the demonstration "How White is White?" I use a light wash of lemon yellow and cerulean blue to find the general shape of the main mass of foliage. While the wash is still wet, I add more cerulean blue to the tops of the masses where they're touched by the sky. I also add raw sienna and cobalt blue to the wash, darkening part of it and suggesting leaves nearer to us. There are no edges within this wash—I'm just after light, values, and color change. I also give shape to the clouds by painting their dark undersides (alizarin crimson, yellow ochre, and cobalt blue).*

DETAIL. *The darks in this detail are a second wash, glazed over the trees after the first, lighter, wash has dried. I use yellow ochre and cobalt blue for the areas turning from the light; these two colors give me a fairly dull green. For the out-of-light areas, tucked under the leaf mass, I use Winsor green, ultramarine blue, and a touch of burnt sienna. You can see the first wash within the mass and at its outer edges. The light color suggests distant foliage and gives added depth to the design.*

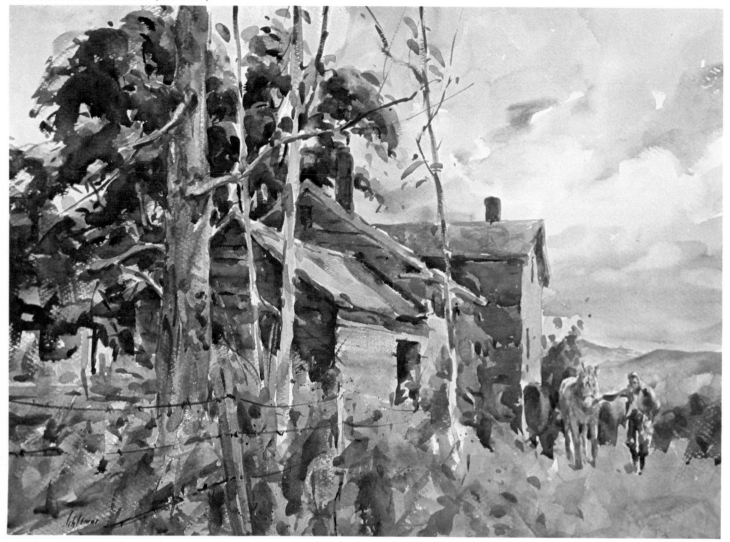

STEP 6. *I finish the out-of-light sides of the building, the grass, the horse, and the figure. I don't jot the grass in arbitrarily. Instead, I use the brush in a manner that suggests grass, always thinking of the layers of new and old growth. Each time I make a stroke, I concentrate on the nature of the edge: should it be hard? or should it be soft? I spatter the foreground for texture and then refine these accidental marks. The light/dark contrast pulls the foreground toward you; in fact, I exaggerate these contrasts in order to convey the exciting quality of the day.*

DETAIL. *The area closest to us naturally has the most detail—you can see the knot in the tree, the texture in the bark, and the burrs on the wire. Notice the abstract quality of the darks in the grass and the distant trees. They tell about the light—and let the viewer imagine the details. The edges vary greatly. Sharp, no-light darks in the distance are softened by superimposed rough-brush marks. The tree on the right is textured with a few crisp, no-light marks, while rough-brush strokes suggest the shimmer of light on its broken surface. The side directly in light is crisp and hard. The waving grass absorbs a lot of light—and, as a result, has many soft edges. This variety is typical of nature, especially on a day characterized by flickering light.*

DETAIL. *There's great variation within the sky: soft edges, hard edges, and even a few rough-brush marks. I've also left some of the water marks; in the upper left, for example, they suggest where one cloud comes in front of another. To the right, the original warm wash of the sky shows through the blue glaze. The colors are thus related to one another—they're not separate, disjointed spots.*

DETAIL. *The man and horse are part of the landscape. You can see how the broken washes of the shirt and the left-hand tree both suggest the same popping quality of light. I should note that the "simplicity" of this figure is a result of my careful preliminary drawing. Because I thought hard about him in the beginning, I can now make him look as if he were just dashed in.*

DETAIL. *The out-of-light sides of the buildings are painted with cobalt blue, ultramarine blue, and cadmium scarlet. I use a lot of water, so the warm first wash will show through the glaze and suggest areas of reflected light. I vary the wash in order to suggest the age of the farm—I don't want a flat, mechanical perfection! I rough-brush some out-of-light color over the in-light side of the barn; that suggests little shadows cast by the grain of the old wood and also varies the edge (a broken edge) of the corner where the dark and light sides of the building meet. This broken edge also helps suggest the age of the structure. The eaves are the darkest, most colorless areas (ultramarine blue and alizarin crimson). The door is first painted with raw sienna, a warm color that lets you get inside the building. Ultramarine blue and alizarin crimson are added for the cold, dark interior. Notice that I use a broken edge in this area, too.*

8. Afternoon Light

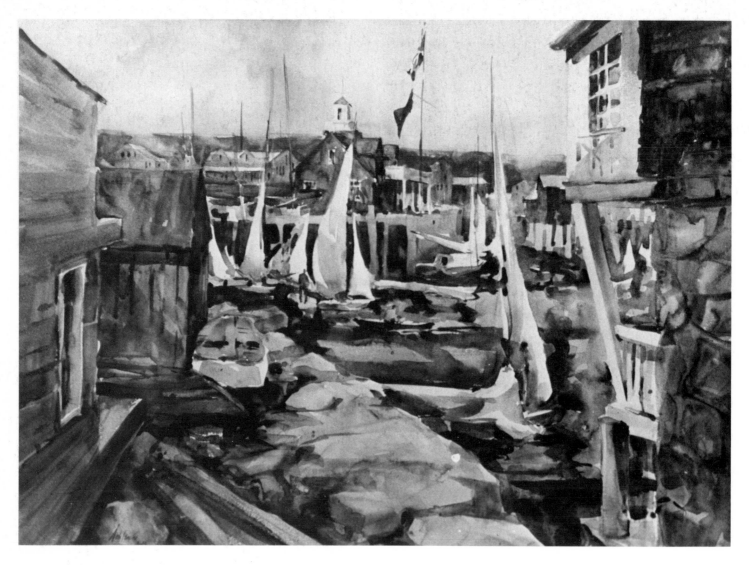

SUNDAY AT SANDY BAY, ROCKPORT, *22" x 30" (56 x 76 cm), collection of Edward and Elizabeth Franco. This is busy Rockport Harbor, dominated by the same yacht club that appears in the following demonstration. The sailboats catch the light and thus become my center of interest. I exaggerate the darks so that the lights really pop. The light areas are framed by the houses on the left and right. The light on the nearby porch keeps the eye high in the picture—and directs it toward the sailboats. By contrast, the lower part of the picture is dark and quiet.*

In this demonstration, we'll visit Rockport Harbor at the end of the day's races. The foreground boat leaves the action, while the distant boats are at rest, their crews exhausted.

LIGHT. Unlike the flickering light of the preceding demonstration or the soft light of the street scene in the second demonstration, afternoon light is strong and warm, a crisp light that creates equally crisp edges. In this case, the sharpness of edge not only matches the brightness of the day; it also suggests the solidity of the boats—a quality obvious to anyone who's ever heard them bump into one another. Interest is added to the picture by a special kind of light: the warm light coming through the translucent sails. Because of the large expanse of the sky and water, the picture is cool. I play up the warm color of the Sandy Bay Yacht Club and the foreground boat in order to keep the picture from going too blue.

KEY. The lights and midtones are close in value—slightly above middle C. The darks are low, so they can be seen. This contrast adds extra excitement to the picture. Because the darks are low, the viewer will see the foreground figure and yacht club first. If I'd wanted the viewer to see the sails, I'd have kept the midtones and darks close; then the lights would pop.

PAPER. I use a sheet of Arches 260-lb cold press, cut in half (25″ x 20″/63.5 x 51 cm). That gives me a horizontal shape, appropriate to the breadth of the harbor. The paper takes washes quickly and cleanly—a prerequisite when painting a sunny day. It can also stand a good beating, so I can correct and rework without doing too much damage to the washes.

PRELIMINARY SKETCHES. As I hope the previous demonstrations have shown, you can't paint a subject till you've gotten involved with it. It's like working in a life class; I like to talk while painting the subject—that way, I learn something about the model's personality. In this case, I spent a number of summers rowing around Rockport Harbor, studying the racing boats and painting rapidly. I had to get *among* the boats, for there was no way I could understand the subject from the dock.

We've already seen how closely the design of a painting is related to its theme; in fact, the edges and directionals are often more important than the individual objects. Figures 47 and 48 illustrate this point. They're two of the countless sketches made from my little boat. Figure 47 was done on a quiet, lazy, fairly windless day. I was struck by the shadow on the sails, so painted them *first*—then I did the sky and water. I tried to suggest the quiet of the day by using a lot of static vertical lines and by keeping the water soft and relatively inactive. Figure 48 was painted in the middle of a race and is, as a result, much more lively. I was struck by the white sails against the sky—and so painted the sky first, claiming my whites in the process. Opposing diagonals emphasize the movement of the boats; for example, I swooped in the front edge of the sail nearest us and then immediately painted the water with a stroke moving in the opposite direction. Such a "reverse repeat" always adds excitement to a painting. Notice also the hard, lively edges in the water.

PLANNING THE COMPOSITION. I use both kinds of movement when drawing the present design. In the distance, static horizontal and vertical lines suggest the quiet, protected area near the dock. In the foreground, a boat is only halfway out of the action in the open sea. I therefore have more activity in the water. The angle of the water parallels that of the boat, thus further emphasizing its movement. The boat is placed way to the left—you sense that it's covered a lot of territory. To counteract the boat's leftward movement, I've added the large warm mass of the yacht club. It pulls your eye back into the picture.

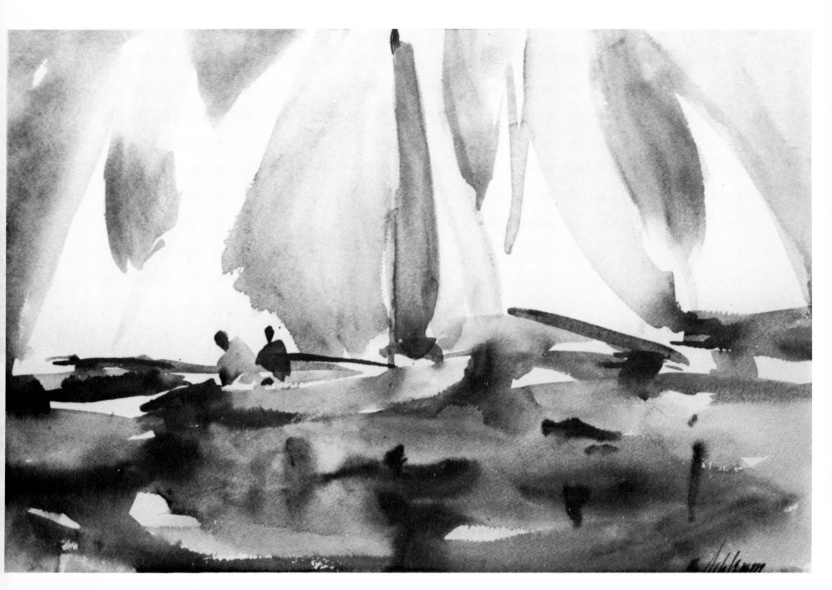

FIGURE 47. *Soft edges and static horizontal and vertical lines suggest a fairly calm day in the harbor.*

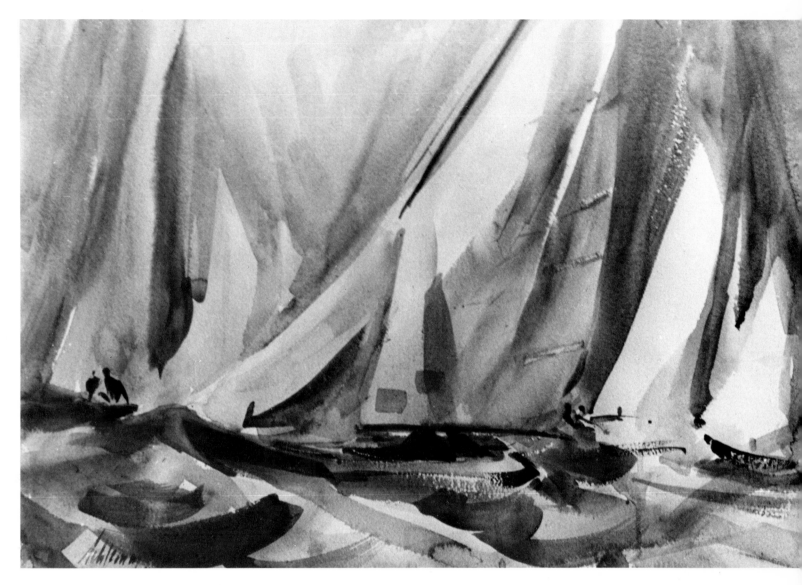

FIGURE 48. *Diagonal lines and hard edges make the viewer feel the excitement of being in the middle of a race.*

STEP 1. *The drawing is held together by the contrast of horizontal, vertical, and diagonal lines. As in the preceding demonstration, I try to make the figure look relaxed and alive. He's balancing himself in the boat, shifting his weight from one foot to the other. The figure is my hardest drawing problem—and I'd never start painting till I was sure I had him right.*

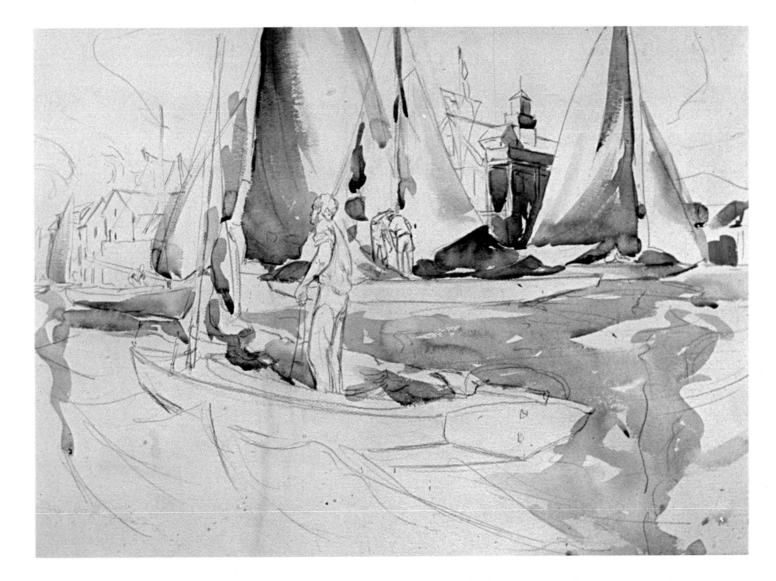

STEP 2. *I claim my lights by painting the darker surroundings: the out-of-light sides of the sails and the yacht club. I use yellow ochre mixed with cadmium scarlet, cerulean blue, and cobalt blue. The blue changes as the object goes more strongly out of the light. The strokes curve to suggest hanging and blowing sails. I do sails and reflections together—they're both part of the same big shape. As I work, I think of gray as a color, a color that needs to be related all over the picture. We did the same with the bright colors in our flower demonstration; but now the effect is much more subtle. Notice how the grays to the right are balanced by the one upright gray mass on the far left.*

DETAIL. *Things are happening in the grays. For example, I use more red in the yacht club so as to distinguish it from the sails. Under the porch, there's less light than on the club's cupola—the cupola is therefore lighter in value and warmer in color. Warm light (yellow ochre) bounces into the bottom of the sail nearest to us and shines through the jib on the far right. Notice that the side of the jib, while translucent, is also dark; it remains an out-of-light value. The grays look dark at this stage— but only because they're against the pure white paper.*

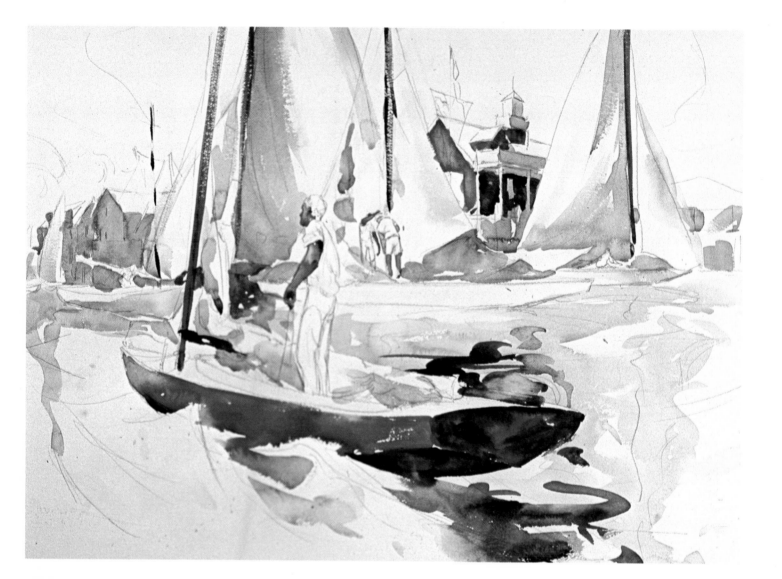

STEP 3. *I creep up on the vivid red boat by first doing the buildings on the left. The farther building is lemon yellow with cerulean blue; the nearer, cadmium orange also grayed with cerulean blue. I get air into the washes by messing them up with a thirsty brush. I do the in-light side of the yacht club (raw sienna and burnt sienna grayed with cobalt blue), adding ultramarine blue for the out-of-light area under the porch. The flesh of the sailors is yellow ochre, alizarin crimson, and cobalt blue—and looks dark against the light sails. I use cadmium scarlet for the foreground boat, adding cadmium orange to move it toward the light and alizarin crimson to move it away. I break the wash where light reflects up from the dancing water.*

DETAIL. *The boat is the strongest warm note in the picture; it's the star! Here you can see the different lights at work. The stern was painted with cadmium scarlet and alizarin crimson. Extra alizarin crimson is added to darken it. Cobalt blue reflects into it from the water. Ultramarine blue is added to the darkest, most colorless parts of the boat (under the stern and the lip of the deck). As you can probably see, I worked wet in this area—color always sings in a wet wash. I paint the reflection of the boat with lively, dancing marks, running the hull of the boat into the water, so the two are related to one another.*

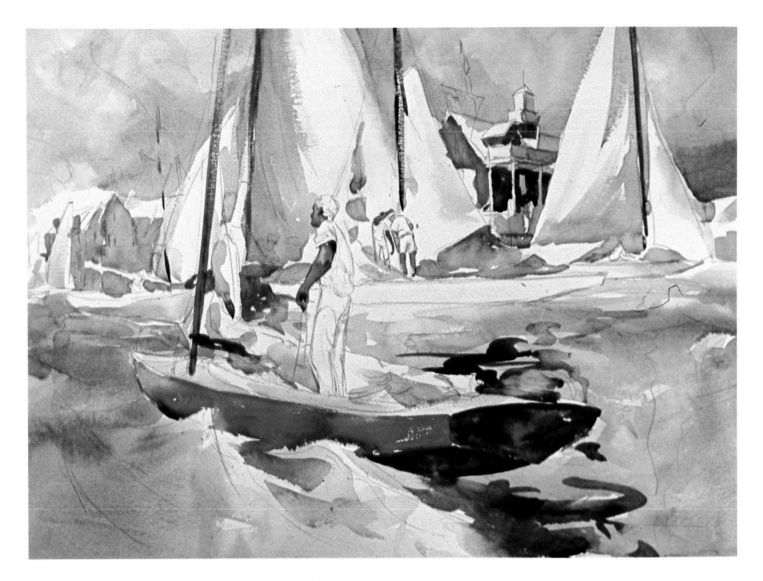

STEP 4. *Now I do the sky and water, my big midtone pieces. The sky wash is graded from yellow ochre (near the sun) to cadmium scarlet (farther from the sun). I add cerulean blue and cobalt blue as in previous demonstrations. Although I darken parts of the sky to accent the sails, the out-of-light sides of the sails are still darker than the sky (the same principle we noticed when painting a white house). The sky color reflects warmer in the water. Notice that the warm color hits not only the water but also the wet deck of the foreground boat: the bow catches some yellow ochre, while the stern, moving from the light, has more of the cooler cadmium scarlet in the mix.*

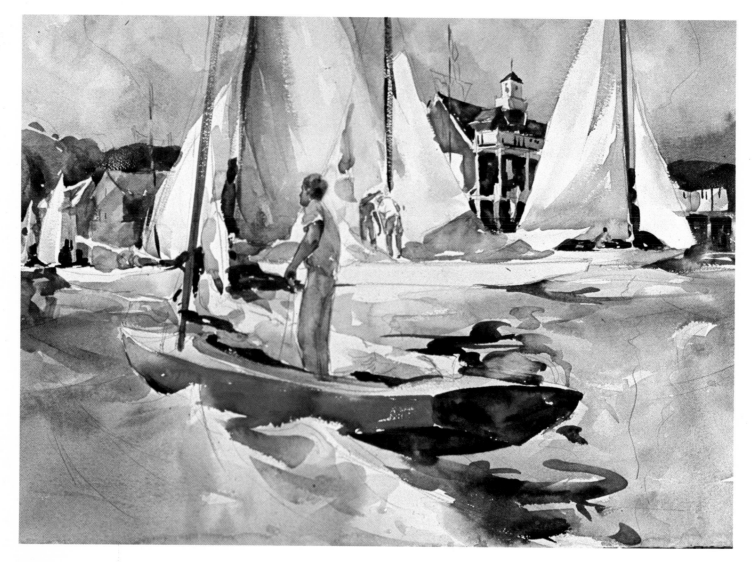

STEP 5. *I use ultramarine blue, alizarin crimson, and burnt sienna to paint the dark, no-light area under the wharf and the stern of the foreground boat. The colors break up in the wash. Even these darks have air in them. The clothing of the distant figures is grayed by atmospheric perspective. The foreground figure wears a blue shirt—and pants whose color is closely related to that of the deck. The closeness of color helps hold the shapes together.*

DETAIL. *The area of background trees is first painted with cerulean blue and yellow ochre. While wet, more cerulean blue is added to the top of the trees (sky color), more yellow ochre to the sides facing the sun, and cobalt blue to the area turning from the light. As I've previously noted, I wouldn't use a color like ultramarine blue in this area; I save that for my real darks. Besides, I also happen to like cobalt blue—and so use a lot of it! Remember: we're not automatons, mixing our colors according to some formula. Likes and dislikes play a large part in how we work.*

I try to keep the shapes in this area as simple as possible. Since I'm saying a lot about sails in this picture, I emphasize them by an expressive repetition of pointed sail-like shapes in the trees and the eaves of the buildings. The cast shadow on the orange house is cobalt blue, grayed with yellow ochre and cadmium scarlet. I use lots of water, so the wash is transparent and full of air.

DETAIL. *Notice the simplicity of the sails; I could paint the seams in the cloth, but that wouldn't add anything to the picture. The dark roof of the yacht club is first washed in with cobalt blue and raw sienna. I add more raw sienna when doing the dormer facing the light. I also use ultramarine blue, alizarin crimson, and burnt sienna for the no-light accents around the porch railing and under the wharf. Notice how light the trim looks, now that it's surrounded by darks! Notice, also, the broken edges around the yacht club. Beautiful edges are like overly madeup women; I always wonder what they're really like. This is a working club, and the rough-brush edges give it character.*

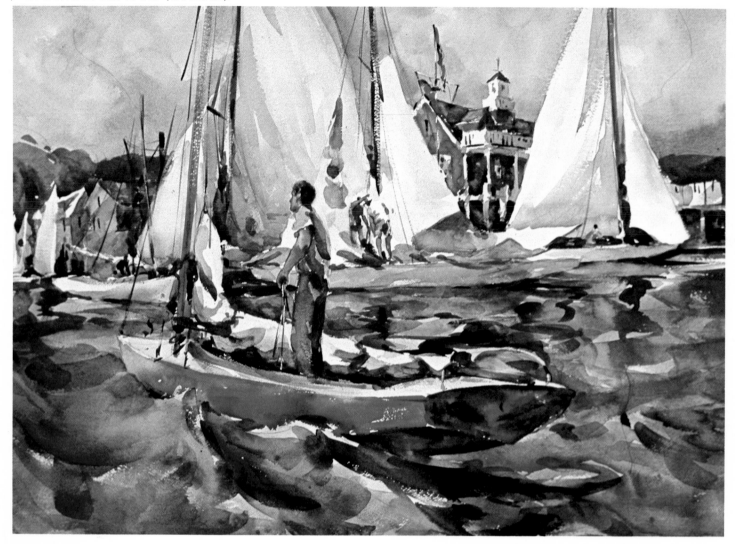

STEP 6. *The boat in the distance presents a flat side to us. In-light, it's painted with yellow ochre and alizarin crimson; I use more cobalt blue as it moves from the light. Variations in the wash add to what I think of as the "pop-pop-pop" quality of the light—the excitement when light bounces back and forth among the moving forms. I use dark glazes to kill some of the light in the water; that makes the sails stand out. Some of the original wash can be seen, however; as we've seen in previous demonstrations, this gives a sparkle to the reworked area. The dark reflections emphasize the height of the masts while also framing the red boat and keeping the viewer's eye in the picture.*

DETAIL. *The front of the shirt is touched with yellow ochre while the back catches cool light (cerulean blue) from the sky. The pants are basically cobalt blue and burnt sienna, with raw sienna in the light and cerulean blue in out-of-light areas. Darks connect the shirt to the pants—and the figure to the boat. As a result, the man belongs to his surroundings. Imagine how he'd look if I'd given him purple pants and a yellow shirt! The darks around the background figures also connect them to their boat. I keep the edges hard in order to emphasize the crispness of the light.*

DETAIL. *The big swell in the water is painted with cobalt blue, ultramarine blue, and cadmium scarlet. Yellow ochre is added to the in-light side, while the blues predominate on the out-of-light side. I made the trough to the far right particularly dark in order to emphasize the boat's diagonal movement into the picture. Notice how exciting the foreground strokes are. I'm working for a feeling of movement—and I can't see much activity if I spend all my time on the dock.*

Conclusion

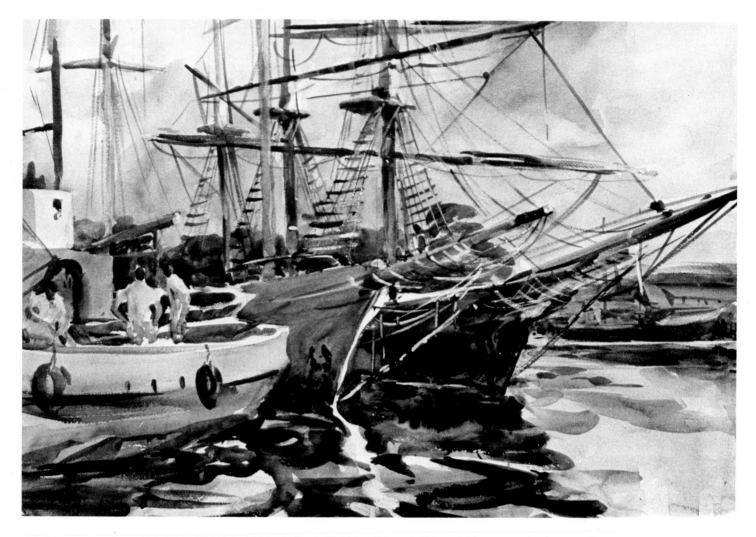

ROCKY NECK, 1976, 22" x 30" (56 x 76 cm). *The old boat was in for repairs and all the local painters were working on the nearby wharves. Halfway through the picture, I noticed that the ropes and pulleys in my painting were attracting more attention than the center of interest: the bows of the boats. To correct this, I ran a slightly darker wash over parts of the sky, lowering the contrast between it and the rigging and thus making the whole area less obtrusive.*

As a painter, you shouldn't learn "how to do." You should learn how to *think*—then you'll be able to tackle anything. It's your job, as a student, to practice the craft of painting—the actual laying on of paint. The teacher helps you see the beauty and truth of what's around you. Use the teacher. Go to him or her to study your weaknesses. Progress comes from developing these weak spots. Give them everything you've got. The strengths will take care of themselves. Whistler, the great portrait painter, never thought that he could do the figure. Once he had a woman pose for over eighty sittings. She ran off, thinking the painter mad. But in the end he got a masterpiece.

Stop and work on your own, too. Associate with good artists. And if none are handy, go to the museum. When you look at paintings, you talk to their creators. See lots of art—and keep good company.

And don't be afraid of being influenced. After all, a teacher is supposed to inspire the student. But don't let the teacher become a crutch. When you build on someone else's style, you build on sand. Try instead to understand the attitudes both of your teacher and of other painters. *Why* do they paint the way they do?—not *how* do they do it? By thus studying the thinking behind the work of other artists, you'll gradually begin to develop your own taste. Build on that taste and knowledge; you'll build on a rock. For that taste is really your most important painting tool, a tool far more important than palette and brushes.

So have convictions. That's what life is all about: life is conviction. Discover yourself. And paint what you are!

Bibliography

Carlson, John F. *Carlson's Guide to Landscape Painting*. New York, Dover, 1973. (paperback)

Curtis, Roger. *How to Paint Successful Seascapes*. Edited by Charles Movalli. New York: Watson-Guptill, 1975.

da Vinci, Leonardo. *The Notebooks of Leonardo da Vinci*. Edited by Jean-Paul Richter. 2 vols. New York: Modern Library, 1957.

de Pantorba, Bernardino. *Sorolla*. Madrid: Compania Bibliografica Espanola, SA, 1963.

Doerner, Max. *The Materials of the Artist: And Their Use in Painting with Notes on the Techniques of the Old Masters*. Translated by Eugen Neuhaus. Rev. ed. New York: Harcourt Brace, 1949.

Gardner, Albert Ten Eyck. *Winslow Homer*. New York: Bramhall House, 1961.

Gaunt, William. *Impressionism*. New York: Praeger, 1970.

Graves, Maitland E. *Art of Color and Design*. 2nd ed. New York: McGraw-Hill, 1951.

Gruppé, Emile. *Brushwork*. Edited by Charles Movalli. New York: Watson-Guptill, 1977.

Hawthorne, Charles W. *Hawthorne on Painting*. New York: Dover, 1938. (paperback)

Henri, Robert. *The Art Spirit*. Edited by Margery A. Ryerson. Philadelphia: Lippincott, 1960. (paperback)

Hoopes, Donelson F. *Sargent Watercolors*. New York: Watson-Guptill, 1976. (paperback)

Hunt, William Morris. *On Painting and Drawing*. New York: Dover, 1977. (paperback)

Ormond, Richard. *John Singer Sargent: Paintings, Drawings, Watercolors*. New York: Harper & Row, 1970.

Whitney, Edgar. *Complete Guide to Watercolor Painting*. New York: Watson-Guptill, 1974.

Index

Note: Names of paintings appear in *italics*.

Edited by Bonnie Silverstein
Designed by Bob Fillie
Set in 11-point Bookman